COLOR PHOTOGRAPHY

COLOR PHOTOGRAPHY

History, Theory, and Darkroom Technique

Peter Glendinning
Associate Professor of Art

Michigan State University

Prentice-Hall, Inc. *Englewood Cliffs, New Jersey* 07632

Library of Congress Cataloging-in-Publication Data

GLENDINNING, PETER, (date)
 Color photography.

 Bibliography: p. 113
 Includes index.
 1. Color photography. 2. Color photography—
Processing. I. Title.
TR510.G54 1985 778.6 84-18267
ISBN 0-13-152174-8

Interior design and editorial/production
 supervision: Lisa A. Domínguez
Cover design: Lundgren Graphics, Ltd.
Page layout: Gail Cocker, Peggy Finnerty, and Jim Wall
Color insert layout: Peggy Finnerty
Manufacturing buyer: Harry P. Baisley

Cover photograph from *The Baker Woodlot Series,* by Peter Glendinning. Hasselblad F/CM camera and 80mm lens on tripod, f8, five minute exposure after dark, with Kodacolor II film. The photographer moved to various spots both in and out of the field of view, and exposed the scene to approximately 60 bursts of light from a Vivitar 285 flash unit. Filters over either the lens or flash unit produced the various colors. Photographs from this series have been exhibited in numerous one-person and group exhibits.

Printed in the United States of America

10 9 8 7 6 5 4 3 2 1

0-13-152174-8 01

Prentice-Hall International, Inc., *London*
Prentice-Hall of Australia Pty. Limited, *Sydney*
Editora Prentice-Hall do Brasil, Ltda., *Rio de Janeiro*
Prentice-Hall Canada Inc., *Toronto*
Prentice-Hall Hispanoamericana, S.A., *Mexico*
Prentice-Hall of India Private Limited, *New Delhi*
Prentice-Hall of Japan, Inc., *Tokyo*
Prentice-Hall of Southeast Asia Pte. Ltd., *Singapore*
Whitehall Books Limited, *Wellington, New Zealand*

CONTENTS

1 · The History of Color Photography 1

The Prehistory of Photography 1

Color and Light 1
Applications and Observations Linked
to Newton's Theories 2

The Beginning of Photography 2

The First Processes 2
Glimpses of Color 2
The First Color Photograph 4

The Birth of Color Photography 5

A Theoretical Basis 5
Panchromatic Emulsions 6
Interference, Separation, and Screen
Color Processes 7
Color for All: The Integrated Screen
Processes 9
Offshoots of the Successful Screen:
Prints and Dyes 10

A Redefinition of Color Photography 11

Kodak and the New Amateur 11

Last Life for Screens 12
Kodak, Agfa, and Two Musicians Make
 a Revolution 13
The Revolution Is Completed by the
 Color Print 14

Contemporary Color Photography 14

1963: The Year Color Took Com-
 mand 14
The Instant, and Increased ISO in the
 1970s 15
Color Photography in the 1980s and Be-
 yond 16

2 Light and Color: Their Meaning for Photographers 19

Part I Light and Color: Basic Concepts 19

The Physical Phenomena 19

Light Is Energy 19
Light Spectrum 19

Defining Color-Light Phenomena 20
Dispersion 20
Refraction 20
Absorption 22
Scattering 22
Diffraction 22
Interference 23
Fluorescence 23

A Theoretical Vocabulary 25

Color Description 25

Value or Brightness 26
Hue 26
Saturation or Chroma 26
Making Color with Light 26
The Additive Color Theory 27
The Subtractive Color Theory 27

Part II The Eye and Mind: Receptor and Interpreter 28

The Eye 28

Vision 29

> **Theories of Vision 29**
> **Perception 30**
>
>> *Color and Brightness Constancy 30*
>> *Brightness Adaptation 30*
>> *Simultaneous Contrast 30*
>> *Afterimage 30*

Part III A Common Psychology of Color and Light 31

Light 31

Color 32

> **Color Wheel Definitions 32**
> **The Mood of Color 33**
>
>> *Red 33*
>> *Orange 33*
>> *Yellow 33*
>> *Green 33*
>> *Blue 33*
>> *Indigo and Violet 33*
>> *White 33*
>> *Black 33*
>> *Gray 33*

Part IV Light Source Effect on Color 33

Daylight and the Weather 33

> **Twenty-Four Hours of Light 33**
>
>> *Predawn 33*
>> *Dawn 34*
>> *Morning 34*
>> *Midday 34*
>> *Afternoon 34*
>> *Sunset 34*
>> *Twilight 34*
>> *Night 34*

The Weather 35

> *Rain 35*
> *Fog and Mist 35*
> *Snow 35*

Artificial Light 36

3 Color Film 37

Additive and Subtractive Light Theories: *A Review* 37

Color Film Structure and Process 37

> **A Basic Process Outline 39**

Processing Color Negatives and Transparencies 39

> **Color Negatives 39**
> **Color Transparencies 42**

Into the Darkroom with Film 42

> **Before and After Processing 42**
> **Push Processing 49**

The Balance of Light Color and Film 51

> **Color Temperature 51**
> **Daylight and Tungsten Emulsions 52**
> **Infrared Emulsions 53**
> **Color Conversions: Making Light and Film Match 53**
> **Light, Film, and Filters: Mireds for Co-ordination 53**
> **CC Filters and Fluorescent Light 55**
> **Reciprocity and Color 55**

Instant Color Processes 57

> **Polacolor 57**
> **Polaroid SX-70 60**
> **Polachrome 61**

Color Film Stability 64

Unprocessed Film 64
Processed Film 65

 4 Printing
Color 66

Four Print Systems: Basic Theory 66

Color Negative to Positive Print 66
Color Transparency to Reversal
 Print 68
Color Transparency to Dye Destruction
 Print 68
Ektaflex PCT Process for Negative and
 Reversal Printing 69
Paper Supports 69

The Color Darkroom 72

Lightleaks 73
Safelight 74
Easel 74
Enlargers and Filters 74

 Neutral Density 76

Color Print Viewing Filters 77

 Voltage Regulator 77

Temperature Control System 77
Processing Drum and Motor Base 77
Notebook 79
Safety 79

Print Processes: Step by Step 79

Standard Negative/Transparency for
 Print Balance 79
Color Print Evaluation 82
Filter Pack Changes 83

Techniques Beyond the Basic Print 97

The Contact Sheet 97
Burning and Dodging 98
The Color Analyzer 99

**Adjustment for Paper Emulsion
 Changes 103**
Printing Color in Black and White 103
**Making Color Transparencies from
 Color Negatives 104**

Print Finishing Techniques 105

Retouching Prints 105

Wet-Brush/Dry-Dye Technique: Prints from Negatives 105
Pencil Retouching: Prints from Negatives 107
Prints from Transparencies 107

Print Mounting 107

Print Permanence 110

Print Storage 111

Bibliography 113

History of Photography 113

Magazines 113

General Technique 114

Color 114

Creative Photography 114

Safety 115

PREFACE

This book is written for every photographer who has wondered how film processors transform those strips of plastic film that wind through cameras, into color prints and slides. More precisely, this book is for the photographer who wants to perform that magic in his or her own darkroom!

Of course, we won't get involved in the operation of mechanized snapshot printers, or rules for snapshot photography. We *will* study the fascinating history of color photography and learn how the medium has grown in its 150 year lifespan to include a wide range of color processes.

We will examine color theory in a depth appropriate to the importance of the subject for photographers. Painters are not the only ones to whom the language of color and light is important! We will learn a basic vocabulary that may be used to open our minds to some of the marvels of vision and light. Theories of light and color are among the topics that any creative photographer will find useful here.

The tool of our trade, color film, and the darkroom processes that take it from exposure to final print or transparency, are covered extensively. Strategies for proper color film and light source balance, lab techniques that can assure proper negative and transparency film development, and slide and negative storage systems, are among the wide variety of topics we will explore. We will also examine four major darkroom processes for printing color, with step-by-step illustrations as well as an analysis of changes in the print which occur during each step. Printing techniques for both negatives and transparencies are covered in depth, with helpful suggestions on everything from safety and color balance, to print spotting and storage.

What is color? How are color prints made? Who, what, when, where, and how did it all happen, from the first color photographs to mine? If such questions get your inquisitive and creative impulses stirring, then you will find answers here. More importantly, you will gain a level of confidence in your technical knowledge that will allow you to go out and answer the tougher questions: "How can I incorporate my technical skills in photography with a personal response to subject matter?" It is the challenge contained in that question that makes color photography a hobby, craft, and profession of unlimited potential.

This book was written in response to a simple demand from many of my students in introductory color photography courses: "Stop cluttering our notebooks with all your technical lectures, and manufacturer's handout sheets, and order a *book* for us!" They wanted a book that would cover the historical development of color photography as well as contemporary theory and darkroom techniques, that they could use whether they were enrolled in a course or not. When I explained that I had been looking for such a book in each of my eight years of teaching, their instant answer was, "Write one!" Without their initial encouragement, this book would not have been started. Without a number of other people's help, this book would not have grown to be useful beyond the classroom, indeed it would not have been finished. My thanks go first and foremost to my wife Bianca, and our children Joseph and Rose, for their love and support. Also, to my parents, whose love allowed me to be myself. The folks at Eastman Kodak Company, Unicolor Photo Systems, Durst Enlargers, Polaroid Corporation, Ilford Corporation, and the Photo Connexion of Lansing, who gave tremendous technical and research support. Beverly Adams deciphered my notes and produced coherent illustrations. And, special thanks to Lisa Domínguez, editor nonpareil, and Bud Therien, Jean Wachter, and Steve Tyriver of Prentice-Hall, whose professionalism is unexcelled.

COLOR
PHOTOGRAPHY

1 THE HISTORY OF COLOR PHOTOGRAPHY

The history of color photography is much the same as that of the development of any other great technical achievement, a story of hopes and dreams, genius, success, and failure.

The Prehistory of Photography

Color and Light. Before color *photography* was of concern, there was first a search for the meaning of *color*: what was it, how was it produced, and what allowed humans to perceive it? The point at which these questions began to be answered by scientific reasoning, rather than alchemical mystification, was the year 1611. It was in that year that Antonius de Dominus of Venice postulated that the sensation of color is the result of an object's absorption of white light. Red, green, and blue, according to de Dominus, were colors from which all other colors could be made. As incomplete as his conjecture was, he had hit upon workable basic theories of color and light.

In 1666 Sir Isaac Newton used a prism to prove his theory that white light was not a single entity but rather a package made up of numerous colors of light blended together. His separation of white light into a solar spec-

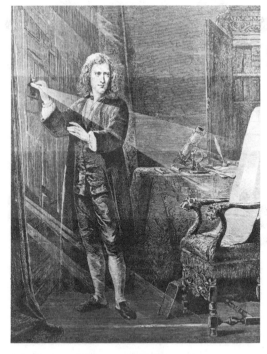

1-1 Sir Isaac Newton and his prism, from an old woodcut.

trum of discrete color bands, and his addition of rays of red, yellow, and blue light to pro-

duce white light, was the beginning of the true scientific study of color and light.

Applications and Observations Linked to Newton's Theories. A practical application of Newton's theory appeared in 1722, when Jakob Christoph Le Blon, a German, published his treatise on three-color printing. He used engraving plates that were inked with red, yellow, and blue inks to print a wide array of colors. His was the first viable three-color printing process.

The first color discovery that might be more firmly linked to the history of photography was published in 1777 by Carl Wilhelm Scheele. Scheele reported that the dark substance produced by exposure of silver chloride to light is actually metallic silver. This fact proved crucial to the invention of silver-based photography, but it is his second observation that is of interest in terms of color. By exposing silver chloride to a spectrum of light rays through a prism, he discovered that the chemical changed to metallic silver with varying intensity, depending on the *color* of light exposing it. He found the compound to be much more sensitive to light from the blue-violet end of the spectrum.

In 1802 Thomas Young established that an earlier theory of Christian Huygens that light travels in waves of specific length and frequency was correct. He also introduced his own theory of color vision, which was based on the assertion that the human eye is sensitive to only three distinct wavelengths of light: those corresponding to the colors red, green, and blue. Our ability to perceive colors other than those three, Young stated, was a result of the brain's ability to fuse perceptions of two or more of the "primary" colors into other colors. His statement was a clear definition of the *additive theory* of light: that white light is made up of red light, green light, and blue light, and that all other colors in the visible spectrum can be made by a blending of two or more of these light colors. His was a theory without recordable proof,

because in 1802 no system for preservation of light pictures existed.

The Beginning of Photography

The First Processes. In 1826 the first photograph was made by Joseph Nicephore Niepce, a Frenchman. In 1839 the first practical process for making photographs was introduced by his business partner, Louis Jacques Mandé Daguerre. The *daguerreotype* was a direct positive picture on a silver-plated sheet of copper. That same year it was joined by the *talbotype*, a product of the mind of William Henry Fox Talbot of England. Talbot's process utilized a paper negative to make numerous paper positives. Both inventors were subjected to bouts of frustration by the response of viewers, who were amazed at the pictures drawn from life by the lens but curious as to the absence of color. It was *color* photography, rather than the black and white of the daguerreotype and talbotype, that was the ideal.

Color photographs were made almost immediately in 1839, by enterprising photographers who dabbled in paints and pastels as well! Hand-coloring of black and white photographs by various means was a widely practiced art for 100 years. While its popularity diminished with the introduction of modern color processes, it is still used by a number of photographers.

Glimpses of Color. In 1840 Sir John Herschel of England made an observation which held possibilities for color photography. He found that a silver chloride solution coated on paper became colored in conformance to the rays of light cast on it by a prismed solar spectrum. Shortly thereafter, Edmond Becquerel and, more successfully, Abel Niepce de Saint-Victor (Nicephore Niepce's nephew), researched the color sensitivity and color-recording capabilities of the daguerreotype.

1-2 Nicephore Niepce: View from a window at Gras, 1826. The world's first photograph. Courtesy Gernsheim Collection, Humanities Research Center, University of Texas at Austin.

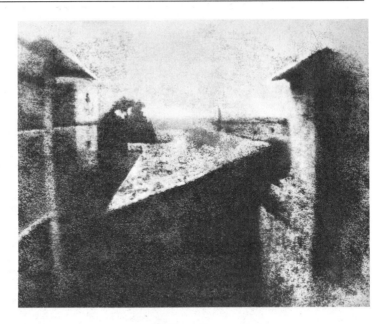

1-3 J.B. Sabatier-Blot: Louis J.M. Daguerre, 1844. Daguerreotype. The inventor of the first widely practiced photographic process, and partner of Niepce. Courtesy International Museum of Photography, George Eastman House.

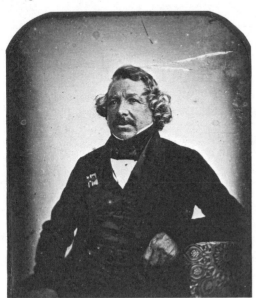

Saint-Victor exhibited a number of "heliochromes" at the Paris Universal Exhibition in 1867. These full-color daguerreotypes were made possible by the color response of silver chloride noted earlier by Herschel. Saint-Victor sensitized his plates with this compound, whereas most daguerreotypes were sensitized by silver iodide and bromide. There were two major problems with the process. First, the exposure time was extraordinarily long. Second, the pictures faded quite rapidly on exposure to light. During the exhibition, Saint-Victor was required to make constant changes in his display!

The claims of the Reverend Levi L. Hill, a Baptist minister from Woodkill, New York, that he had invented a process for color photography (which he named the *hillotype* process, Americans having egos at least equal to those of the French and English), almost brought the business of commercial portrait photography in America to a halt. In 1851, while would-be patrons delayed their portrait sessions in anticipation of a color process, Hill was pressured by all interested

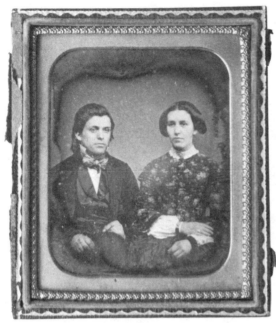

1-4 Photographer unknown: Portrait of a man and woman. Daguerreotype. The jewelry on the woman's collar and wrist has been hand-painted in gold. Author's collection.

parties (especially photographers who lost business during the time!) for an explanation of his claimed achievement. It is likely that Hill's color daguerreotypes resulted from a process similar to that of Saint-Victor, but after much delay, and claims by Hill that he was awaiting the proper time for revelation of his secret, he was denounced as a charlatan. His color pictures were examined and approved of by a number of experienced photographers, among them Samuel B. Morse. It seems likely that he did achieve some success, although it was more than likely accidental. At any rate, he could never repeat his initial work.

The First Color Photograph. May 17, 1861, proved to be a day of importance for a 30-year-old English physicist, for the scientific study of color and color vision, and for photography. On that day James Clerk-Max-well gave a lecture and demonstration to the Royal Institution in London. His objective was to prove Young's theory of color vision: that the eye is sensitive to only three wavelengths of light and that all other visible colors could be made by a combination of those three. Although his demonstration was important in terms of its relationship to Young's theory, Clerk-Maxwell is perhaps best remembered for his impact on photography. With his demonstration, he made the first permanent color photograph.

Clerk-Maxwell used a photographic process introduced in 1852 by Frederick Scott Archer: the *collodion*, "wet plate" process. It combined the best features of the daguerreotype (sharpness and long tonal scale), and the *calotype* (a negative image from which numerous prints could be made). The "plate" was a sheet of glass coated with silver iodide suspended in a viscous liquid called *collodion*.

Clerk-Maxwell and his assistant, Thomas Sutton, photographed a tartan plaid ribbon. They made three separate negatives of the ribbon through three separate filters. The filters were actually bottles of colored water, one red, one green, and one blue. After they made positive black and white transparencies from the "separation" negatives, the transparencies were projected in register on a white screen by three different projectors. When the projected pictures were colored, each by the filters originally used to record them, a color picture of the ribbons appeared on the screen. Clerk-Maxwell had proven the additive theory of light and had shown a practical, albeit awkward, method for making color photographs.

In actuality, as was discovered by contemporaries of Clerk-Maxwell who attempted their own color photography using his system, the experiment should have been a failure! The collodion emulsion was barely sensitive to red and only mildly sensitive to green, so the "separation" of the picture into its three color components should not have worked. In 1961, on the centenary of Maxwell's lecture, Ralph M. Evans of Eastman Ko-

dak repeated the experiment and found that the red record was made possible by the *fluorescence* of the red dye used in the ribbon.

While Clerk-Maxwell understood the importance of his experiment in the development of color photography, the nature of his inquiry had more to do with theories of color vision. An experimenter in France, however, had the objective of color photography firmly in mind as he went about his work.

The Birth of Color Photography

A Theoretical Basis. Louis Ducos du Hauron developed an *additive and subtrac-*

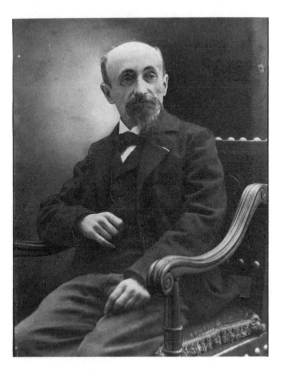

1-5 Photographer unknown: Louis Ducos du Hauron, the theorist who defined the essential color photographic relationships, and proposed processes for their use. Courtesy International Museum of Photography, George Eastman House.

tive theory of color, which with slight modifications, forms the basis for color photography and printmaking today.

In 1862, working without knowledge of Clerk-Maxwell's demonstration one year earlier, du Hauron outlined his theory of additive color photography in a letter to the French Academie de Médecin et Sciences. He proposed the use of red, yellow, and blue to make "separation" positive black and white pictures, which, when seen together colored by the filters used to record them, would render a scene in its normal colors. His choice of colors was determined by an adherence to the theory of color proposed by Sir David Brewster, which unfortunately holds truer for pigments than for light. In 1869 du Hauron was granted a patent for a screen-plate process using his color set. Although for true additive color, red, green, and blue would have been more appropriate, his screen-plate suggestion was a wonderful one. He foresaw a single exposure yielding a color photograph by having the emulsion of the glass plate in the camera become exposed only after the light had first passed through a screen of minute red, yellow, and blue dots. If the black and white plate were developed as a positive and viewed by transmitted light through the same screen, a full-color picture should appear. The screen plate, as we shall see, became one of the most popular methods for color photography.

While du Hauron's screen-plate process was a conceptual milestone, in that it would allow the three separation exposures to be made at one time on one emulsion, it did have some deficiencies. The pictures he proposed would be direct positives, and if more than one photograph of a scene were needed, the photographer would have to make more exposures: there were no prints. Also, the picture was a "light" picture and could be seen by the viewer only because of the blend of colored light transmitted by it. Needless to say, this would preclude the inclusion of such a picture in a book or on a poster!

Included in du Hauron's patent, however, was a second process which solved the problem of making color photography compatible with printmaking. This second process is the basis for most of today's color photography.

The corollary to the additive theory proven by Clerk-Maxwell, is the subtractive theory of color first outlined by du Hauron. The subtractive primary colors are cyan, magenta, and yellow, and they are each the complement of an additive primary color. Whereas additive primaries make color by the *addition* of colored light, subtractive primaries make color by *subtracting* their complements from a white light source.

Du Hauron patented a process that involved photographing a scene through red, green, and blue filters, then making three positive gelatin prints: one cyan, one magenta, and one yellow, printed from their complementary separation negatives. These prints could be superimposed on glass if a transparency were desired, or on paper if a print were to be the final image.

The systems outlined by du Hauron for screen-plate single-exposure color, and for a subtractive process of printing, were the spark which set off a flurry of research into color photographic systems. An astounding coincidence was the publication of a system almost identical to that of du Hauron, in Le Monde just two days after his patent was awarded. The process was invented almost simultaneously by a fellow Frenchman, Charles Cros. He deposited a letter describing his system with the French Academie in 1867, with instructions that it not be opened until 1876. When du Hauron was issued a patent on an almost identical process, Cros found it necessary to publicize his own investigations seven years earlier than he had expected to. Cros's interests ranged well beyond photography, into comedy, medicine, chemistry, and inventions. He developed a theoretical basis for recording sound in the year before Thomas Edison patented the phonograph. His lack of concern for commercial development of color processes left to du Hauron and others the task of further refinements.

Panchromatic Emulsions. As theoretically sound as the subtractive and additive systems were, the collodion process's relative insensitivity to light in the spectrum beyond blue was a major problem. Du Hauron estimated his exposures to be 25 to 30 minutes with a red filter, 2 to 3 minutes with a green filter, and 1 to 2 *seconds* with a blue filter. What was needed for both more accurate black and white, and for solving color photography's puzzle, was a method of sensitizing an emulsion to the full range of the visible spectrum.

The first step toward achieving this goal was taken by a German, Dr. H. W. Vogel. He discovered in 1873 that silver bromide emulsions (such as collodion, and the dry plates introduced that year by John Burgess) could be made sensitive to a wider range of colors by the addition of dyes to their emulsions. Vogel's work brought the sensitivity of emulsions through to green. Experiments by Professor A. Miethe and Dr. A. Traube in 1901 with isocyanine dyes increased photographic sensitivity to yellow and orange. Finally, in 1905, pinacyanol dye was discovered by Dr.

1-6 Advertisement for Ilford's glass-plate black and white panchromatic emulsion. The dyes which expanded emulsion sensitivity were an essential step on the road to color photography. From *The Photo-Miniature* magazine, December 1921.

B. Homolka, expanding the recordable spectrum through red. With the production of the first truly panchromatic black and white emulsions, the first practical processes for color photography were made possible.

During his dye research Dr. Homolka also made an equally important discovery. While it received little notice at the time, it is the chemical basis for most color films today. He discovered *chromogenic* dye production, that is, that certain dyes can actually be produced during development rather than merely being added to an emulsion.

Interference, Separation, and Screen Color Processes. While research continued in the development of truly panchromatic black and white emulsions, other experimenters sought alternative methods for color photography. In 1891 Professor G. Lippman of the Sorbonne presented a report on an *interference* process of color photography. He

coated a glass plate with a very fine grain albumen emulsion, color sensitized by cyanine dye. When dried, the coated plate was placed in a special light-safe holder. Liquid mercury was poured into the plate holder, completely backing the emulsion of the plate with the reflective substance. When the plate was exposed in a camera, light rays first passed through the glass and emulsion and were then reflected back by the mercury. This reflection of light rays back onto themselves caused "standing" waves of light and resulted in an interference pattern being recorded by the emulsion. When the plate was developed, the pattern caused the plate to reflect back to a viewer only those colors of light that were "seen" by the plate during exposure. The color positive could be observed only by reflected light and required a one- to two-*hour* exposure in the camera. While they were a great scientific achievement, the combination of inconvenient exposure times,

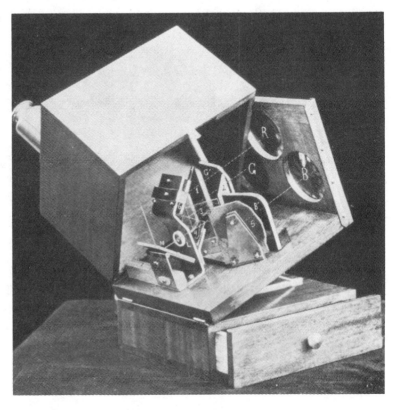

1-7 First photochromoscope of Frederick Ives. Courtesy International Museum of Photography, George Eastman House.

difficulty of viewing, and impossibility of reproduction (by light through the plate, they looked like grossly overexposed negatives) made Lippman plates commercially impractical.

Frederick E. Ives of Philadelphia invented a process which was somewhat cumbersome but did achieve a degree of commercial and practical success. The *photochromoscope* camera had a single lens, but a movable back which allowed three separation negatives to be exposed through red, green, and blue filters. Positive transparencies were made by contact printing the negatives onto glass plate emulsions. These were then placed back into the photochromoscope, which doubled as a viewing system for superimposition of the three black and white positives and the filters used to record them. The *kromograms* appeared, after the laborious process of dismantling and reassembly, in glorious color. In 1893 Ives introduced stereoscopic (three-dimensional-appearing) kromograms, and in 1895 a process for projection of single kromograms. In 1900 his one-shot camera, similar in concept to one invented by du Hauron, allowed all three color separations to be recorded at one time through a series of filters and mirrors.

Du Hauron's vision of a screen-plate color system was made a reality in 1893 by the Dublin physicist Charles Joly. He patented the first line screen, in which red, green, and blue lines were ruled on a glass plate, 200 to the inch. James W. McDonough of Chicago perfected a similar process which

1-8 Photomicrographs of screen patterns of the major color-screen processes. Left: Finlay; Right: Dufaycolor. Courtesy International Museum of Photography, George Eastman House.

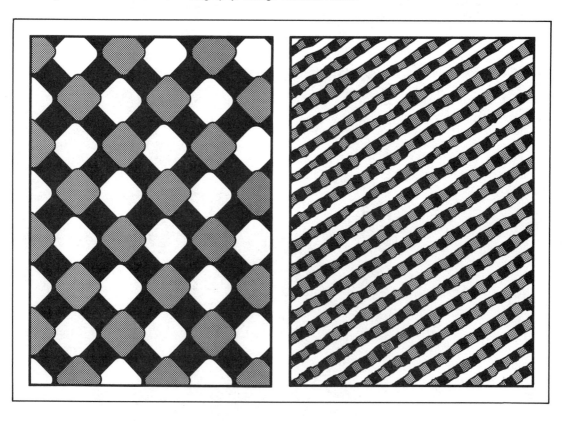

allowed 300 to 400 lines to be ruled. Both processes entailed placement of a lined screen of glass in front of a panchromatic black and white "dry plate." When exposed in a camera, the emulsion was filtered by light passing through the screen, resulting in a black and white negative made up of minute lines exposed by the three different colors of light. A positive made from the negative was then sandwiched with the color screen in register, and a full-color photograph could be seen by transmitted light.

Although Lippman, Ives, Joly, McDonough, and others did formulate workable processes for producing beautiful color photographs, their complicated machinery, inconvenience of viewing, requirements for registration, and/or necessity for three different exposures made these processes barely functional for the professional, and certainly impractical for the rank amateur. They had not reached the goal of a process for color photography that could be used with ease by all.

Color for All: The Integrated Screen Processes. The first decade of the twentieth century was a turning point in the history of color photography, with investigations of various color processes proceeding at a frenzied pace. The screen process was modified by the two brothers Auguste and Louis Lumière of France. In 1904 they patented the first color photographic process that could be used by almost anyone owning a camera. The *autochrome* had a color screen built into the emulsion plate, which did not require the realignment for viewing after development that had been necessary with Joly's process. The plate consisted of a panchromatic black and white emulsion on one side, with a random pattern of minute particles of red-, green-, and blue-dyed potato starch on the other. In a camera, the emulsion was filtered by the starch crystals, which remained intact during subsequent positive development. The black and white positive image, when seen through the starch filters, became a full-

1-9 Advertisement for Autochrome *glass-plates* from *The Photo-Miniature* magazine, December 1921.

color positive transparency of exquisite quality. Exposures were brief enough, one second in sunlight, so that portraits were possible. The autochrome became a huge commercial success. *National Geographic* and other magazines took advantage of advances in printing technology to make extensive use of autochrome reproductions.

During the same period C. L. Finlay worked to perfect his version of the additive integral screen plate. Rather than using lines or a random scattering of dots, Finlay designed a screen that consisted of adjacent

1-10 Advertisement for Dufaycolor *film,* from *Camera Craft* magazine, September 1935.

Red Record

Green Record

Mirrors and Filters

Blue Record

1-11 Illustration of one of Frederick Ives's "one-shot" color cameras. A single image is split by mirrors and filters into three separations.

alternating red and green dots on a blue field. His introduction of the plate in 1905 was followed almost immediately by the Dufay *di-optichrome* plate. The Dufay screen consisted of a field of red with overlapping blue and green lines. "Dufaycolor" was applied to many sheet and roll film sizes as well, as those media gradually replaced glass as a support. It was so successful that it remained available into the 1940s.

Offshoots of the Successful Screen: Prints and Dyes. The variety and success of screen-plate color positive processes available at the turn of the twentieth century sparked research activities into means for both reproduction and improvement of the systems.

In 1909 Dr. J. H. Smith introduced a process for making color prints from color transparencies, which he named *utocolor*. The process utilized dyes that would take on the color of light that exposed them. Unfortunately, the long sunlight exposures required to contact-print a screen positive in this manner resulted in the fading of the original!

Other experimenters turned away from

screen processes in favor of three-color separations. Thomas Manly of England in 1905 developed a process he named *ozobrome*. Bromide separation positive pictures were stripped from their supports, dyed, superimposed on a sheet of paper or glass, and a single color print resulted. This process was the forerunner of *carbro*, a similar color printing process which dominated in the 1930s.

The imbibition process (in which dyes are transferred from a gelatin image to paper) was proposed by Charles Cros, but it was not until 1905 that Leon Didien perfected a form which he named the *pinatype*. Separation positive pictures were used to produce three negative gelatine relief prints, which were hardened depending on their exposure. The more hardening, the less dye of the separation's complement color it could absorb and transfer to the final print. In 1911 Frederick Ives patented a refined version of the dye imbibition process, one that required original black and white *negative* separations rather than positives. To produce the negative separations required for use in his new printing process, Ives and Henry Hess manufactured the Hi-Cro camera. The Hi-Cro was the first camera built to accept a "tripack" of film, three sensitized plates in one film holder. Red, green, and blue separations could be made in "one shot" by means of a somewhat complicated procedure involving filters and mirrors.

Ives's predecessor of the true tripack (in which three separate emulsions are superimposed on one support) was produced the year before Rudolph Fischer would make a great leap in the advancement of color photographic chemistry. In 1912 Fischer discovered that *paraphenyenediamine* oxidized during the development process, and that if certain chemicals were added after this oxidation, they immediately formed insoluble dyes in the metallic silver areas of a black and white emulsion. Fischer proposed incorporating these "dye couplers" into an integral tripack color film. The tripack would consist

of three layers of emulsion, coated one on top of another: the top one sensitive to blue light, the middle sensitive to green, and the bottom sensitive to red. Although Fischer could not control the unwanted migrations of dye from the red to the green layer, and vice versa, his construction of a true tripack emulsion, and the discovery of dye coupling, were crucial advances.

In 1918 F. J. Christenson patented a print process which sidestepped the need for Fischer's dye couplers. His process began with the manufacture of a multilayered emulsion which was *already* dyed, on a paper base. A color print was formed by selective removal of various layers of the dye during a bleach development. The process was revitalized in 1933 as *gasparcolor*, a commercially successful dye-destruction process applied to motion picture film. These processes were just the opposite of the majority of dye-color systems, which depended on the *production* rather than *destruction* of dyes.

A Redefinition of Color Photography

Kodak and the New Amateur. The objective of many researchers into color photography throughout its history was to produce a color system that would be simple enough for amateurs to use yet would yield high-quality pictures. No person felt the commercial potential of such a system more keenly than George Eastman, founder of Eastman Kodak. It was Eastman who, with his introduction of the Kodak camera in 1888 and a film emulsion for it in 1889, had totally redefined the meaning of the term "amateur photographer." Until the introduction of his camera and film system, the photographer, amateur or not, was encumbered with a tripod, heavy glass plates, a rather large camera, and boxes in which to carry all the paraphernalia. The Kodak was half the size of a shoe box and required only the photographer to hold it relatively still and "press the button." No longer were a strong back, understanding of exposure and development, and lots of free time necessities for photographers.

In 1912 Eastman bought Wrattan and Wainwright, Ltd., an English company which manufactured fine panchromatic emulsions. He bought the company both for its fine products and for its research director, C. E. Kenneth Mees. Mees moved to Rochester, New York, where he became the director of Kodak Research Labs and the moving force behind its color research for the next forty years.

In 1914 J. G. Capstaff of Kodak developed a process for two-color separation, reasoning that the tricolor separation techniques of the time were too complicated and cumbersome for most amateurs. A red-filtered negative was developed into a green positive, and a green-filtered negative into a red positive. When the two were sandwiched together, a fair color rendering resulted. While the process was not a commercial success (because as transparencies they could not match the range of the autochrome, even though they exhibited none of its "graininess"), it was extremely significant. First, it was named *Kodachrome*, a name that was

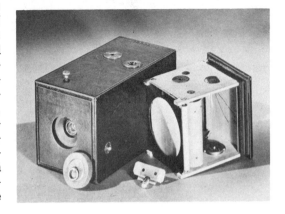

1-12 The No. 1 Kodak camera, introduced in 1888. Courtesy Eastman Kodak Company.

1-13 The 1924 catalogue of products from the Agfa Company included this listing for AgfaColor plates. Impoverished photographers did not shoot color, at $9.00 per box of four 8-by-10-inch plates!

1-15 The transformation of emulsion stock from glass to film was rapid, as the popularity of hand-cameras grew. From *Camera Craft* magazine, April 1934.

1-14 This advertisement for Lumière's Filmcolor marks the swan song of the screen-color era. From *Camera Craft* magazine, April 1934.

used later for Eastman's first color slide film. Second, this was the first commercial *chromogenic* film: the latent image was converted to a color-dyed image through the interaction of dye couplers and the development process.

Last Life for Screens. While research into multiple-layer emulsions and chromogenic processes continued, the addi-

tive screen processes were still popular. In 1920 Agfa of Germany announced *Agfacolor*, a screen plate very similar in image quality to the autochrome, composed of dyed dots of resin impregnated in an emulsion. Both Agfacolor and autochrome, being emulsions supported by glass, were becoming somewhat anachronistic in the late 1920s, when film-supported emulsions were sweeping the marketplace. Both Lumière and Agfa introduced film-supported screen emulsions

which, along with dufaycolor, were available for commercial and amateur use. The days of the additive screen were numbered, however. Research in integral subtractive film by Kodak and Agfa in the 1920s and 1930s would produce a revolution in the meaning and look of color photography.

Kodak, Agfa, and two musicians make a revolution. By 1930 Kodak had begun directing a large part of its energies toward the production of a viable integral tripack film, one that would separate color in one exposure and would produce dyes in the film during development. Kodak's efforts were focused that year by the addition of two young independent researchers to its staff.

Leopold Mannes and Leo Godowsky, Jr., were teenagers when they first met in school. Both originally trained in New York City as concert musicians, but they also shared a second interest: a quest for an integral color film. By 1930 they had been experimenting for almost a decade in the production of multicoated emulsions, working in laboratories financed first by their parents,

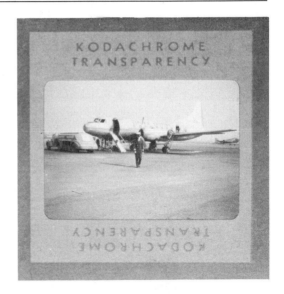

1-17 Photographer unknown: View of an American Airlines plane and pilot, at Hancock Airport, Syracuse, N.Y., c.1947. The placement of Kodachrome transparencies in cardboard mounts proved crucial to its acceptance by the public, and resulted in the "slide show." Author's collection.

1-16 The two musicians who joined forces with Eastman Kodak Company to produce Kodachrome film, Leopold Mannes, and Leo Godowsky. Courtesy of Eastman Kodak Company.

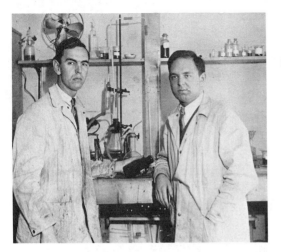

then by an investment on the part of Kuhn, Loeb, & Co., a Wall Street firm. A number of experimental emulsions of their design had been made for them by Kodak, through the help of Dr. Mees. Their decision to join forces with Kodak followed the company's development of new dyes in 1928.

At Kodak, Mannes and Godowsky developed a method for dye-coupler insertion during development rather than during production of the film emulsion; at the same time, the research lab evolved the process for making integral film tripacks. In 1935 the result of the partnership was introduced: Kodachrome, the first integral tripack subtractive color reversal film.

Kodachrome was first marketed as a 16mm movie film and was introduced for 35mm still photography in 1936. The development of the film was, and still is, a very complicated procedure which only Kodak machinery can accomplish.

Shortly after 1936 Kodak took a step that had nothing to do with its chemistry but that ensured the commercial success of Kodachrome. It placed all processed pictures in cardboard mounts to facilitate their projection! This made "slide shows" possible in the home and greatly enhanced the appeal of the film.

Although Kodak was first, it was left to the Agfa Company to introduce a film that fully realized the process originally proposed by Fischer. The 1936 Agfacolor film was the first subtractive reversal color film with dye couplers incorporated in the emulsion. This allowed the amateur to process color film at home, without any of the elaborate machinery required by Kodachrome.

Kodak introduced its version of Agfacolor, called Ektachrome, in 1940.

The Revolution Is Completed by the Color Print. While Kodachrome, Agfacolor, and Ektachrome satisfied a need for high-quality nonscreen integral color films, they all had a deficiency: the public was accustomed to prints.

Color prints were available, but through a process used almost exclusively by commercial photographers. Most color prints of the 1930s and 1940s were made with a process known as *carbro*, for *car*bon and *bro*mide. This complicated process involved separation negatives, black-and-white bromide prints, transfers of colored gelatin, and strict alignment of three colored images. Taking six to eight hours to produce a single color print, it was hardly suitable for mass production of snapshots.

In 1942 Kodak resolved the color print dilemma. The Kodacolor process was modified so that dye couplers were activated during a single development step, producing a color *negative*. When printed on a paper coated with a similar emulsion, a color print was produced. Kodacolor film and prints brought to a satisfactory resolution the system first outlined by du Hauron.

Contemporary Color Photography

1963: The Year Color Took Command. Color slides, and color prints from color negatives, gained steadily in popularity to the point in 1964 when American amateurs began making more pictures in color than in black and white. Events in 1963 made inevitable a dramatic decrease in the use of black-and-white photography by amateurs.

In that year the Ilford Company of England marketed its Cibachrome paper, which produced direct positive prints from color slides. By means of a dye-bleach system, descending from the early gasparcolor, it allowed relatively easy home darkroom printing in color.

Also in 1963 Edwin Land introduced Polacolor film, the color successor to the instant black-and-white process with which he had shocked the world in 1947. A single expo-

1-18 Edwin Land introducing instant photography on February 21, 1947. Courtesy Polaroid Corporation.

1-19 The Kodak Instamatic Camera, c.1963. This easy-loading, easy to use, camera greatly increased the use of color film for snapshots. Courtesy Eastman Kodak Company.

sure, and development of a full-color photograph by the photographer in one minute after release of the shutter, made the new film an immediate success with amateur and professional alike.

Another product of 1963 was merely a change of packaging, but it was one that would produce a manifold increase in the use and popularity of color photography. The Instamatic Camera by Kodak was an inexpensive device, built to be used with easy-loading cassettes of color print film. Color-corrected plastic lenses for these cameras made good-quality simplified snapshot color a reality.

The Instant, and Increased ISO in the 1970s. The color photography advances of the 1970s and early 1980s were notable for the emphasis placed on instant processes. The public as well as manufacturers looked more and more for processes that would close the gap between exposure and completion of the color picture.

In 1972 Edwin Land incorporated the negative and positive sheets into a single film unit, producing the Polaroid SX-70 system. The now-familiar SX-70 photograph contains

more than 16 layers of material and is completely developed within moments of exposure. By coupling automatic exposure and development with automatic focusing, the Polaroid SX-70 Sonar camera made 1978 the year of truly automatic color photography.

During the 1970s Polaroid was also modifying its first instant color process, Polacolor. In 1975, Polacolor 2 was introduced. In 1976 an 8-by-10-inch size for use with large-format view cameras and a motorized processing device were marketed. Some researchers and photographers longed for even larger instant pictures, and Polaroid accommodated them with the development of 20-by-24-inch film and a custom camera. In 1979 Polaroid went even larger, building a three-story-high, 23-square-foot camera with a 2000mm lens. It was used to photograph "The Transfiguration," by Raphael in the Vatican, on four 3-by-9-foot sheets of Polacolor!

There was much activity in color photographic research outside Polaroid as well

1-20 The Polaroid SLR 680 camera and 600 High Speed Color Land Film combine the most advanced instant film and camera technologies. Courtesy Polaroid Corporation.

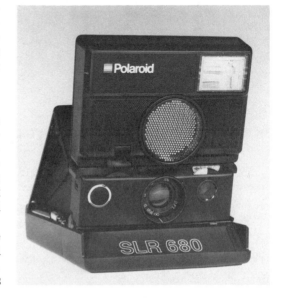

1-21 An experimental Polaroid view camera and 20-by-24 inch Polacolor 2 film have been made available by Polaroid to photographers from a wide range of disciplines. Photograph by Bill Gallery, courtesy of Polaroid Corporation.

during the 1970s. In 1976 Agfa introduced Gevachrome 710, a color reversal film with capability of forced processing to ISO 1000. In the same year, Fuji Film Corporation marketed a high-speed color negative material, rated at ASA 400. Eastman Kodak Research Lab was also still very much in business, producing its version of instant color photography in 1976.

Color Photography in the 1980s and Beyond. The 1980s have seen continued development of new products for traditional color photography. In 1981 the introduction of a by-product of Kodak's research into instant photography revolutionized color printing. The Ektaflex PCT system eliminated the need for running water and strict tempera-

ture controls in the home darkroom. Also in that year, 3M introduced a high-speed 640 ASA color slide film balanced for 3200K lamps, making concert hall available-light photography much simpler.

In 1980, Polaroid introduced Polacolor ER (extended range) film, and in 1981 a second-generation SX-70 system, the 600 Sun System was revealed. Unique photographic opportunities are provided by combining 600 High Speed Color Land Film with the autofocus, built-in flash, automatic exposure, and single lens viewing found in the Polaroid SLR 680 camera.

On April 19, 1983, Polaroid introduced its first film *not* made for a Polaroid camera or film holder. Polachrome CS 35mm Instant Slide film is a line-screen film similar in color-separation concept to the color screen introduced by Joly in 1893. The Polachrome screen is integral with a silver transfer film. After exposure in any 35mm camera, the film may be processed and ready to mount in minutes!

Also in 1983 Kodak introduced its new VR films, with new coupler and dye chemistries. The group includes a film whose ISO 1000 is made possible by a fundamental change in the shape of silver halide grains. VR films are also "DX" marked with four sets of machine-readable codes. These codes will enable cameras and photo-finishing machines to "know" what film they are using! Kodak added to its VR line in 1984 with a new color reversal film, Ektachrome P800/1600. This professional film is designed specifically for "push" processing from ISO 400 to 3200.

In 1981, however, the Sony Corporation completely revolutionized the concept of still color photography. In August of that year it unveiled a still color camera that uses magnetic video discs instead of film. The MAVICA camera, for "magnetic video camera," can record fifty color stills on a reusable disc. These pictures may either be displayed on a video screen or be made into color prints by means of a device similar to an office photocopier.

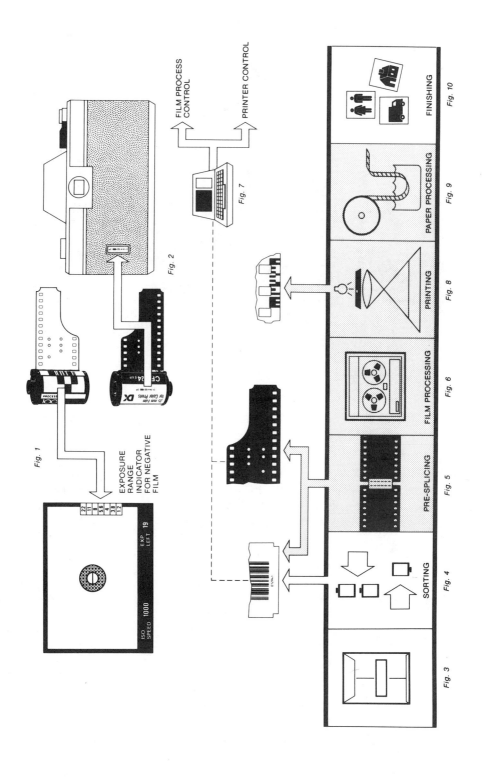

1-22 DX marking of Kodak's VR color films revolutionized both camera design, and processing lab procedures. Courtesy Eastman Kodak Company.

17

1-23 Sony's MAVICA camera, the first production still-video camera, transformed the meaning of color photography. Courtesy Sony Corporation of America.

The elimination of silver as an integral element in the process of color photography is as momentous as the use of color systems to record pictures from inside the human body and from the planet Mars. It also gives the 140-year search for color new meaning— and portends an even more complex future. (See colorplates 2 and 3.)

2 LIGHT AND COLOR: THEIR MEANING FOR PHOTOGRAPHERS

Part I Light and Color: Basic Concepts

Light and color, two of the most commonly used words in the English language, can mean many different things to different people. In the contexts of science, psychology, design, art, and industry, these words vary in tenor and tone, form and content.

An understanding of both the sources and meanings of color and light is essential to us as photographers. After all, the word *photography* has its derivation in the phrase, "writing with light." In order to be effective "writers," we must make a study of both the science and romance of light.

The Physical Phenomena

Light is that which makes visual perception possible, for even the best eyes are useless without it. Before examining its consequences, let us investigate light itself, and the various color components of which it is comprised.

Light Is Energy. Electromagnetic radiation is energy that runs the gamut from alternating electrical current through that which we associate with the sensation of heat. It is differentiated by various wavelengths. Light is the range of electromagnetic radiation from infrared through the visible, to ultraviolet and X-rays. This energy travels in a vacuum at 186,281 miles per second.

Light is formed by the emission of photons by atoms, and the various energy levels of these photons result in light of different wavelengths. These wavelengths not only indicate different energy levels, but different sensations of color as well. The shortest visible wavelengths are approximately 400 nanometers, or 400 thousand millionths of a millimeter. We associate this wavelength with the color *violet*. The longest visible wavelengths are in the range of 750 nanometers and give most people the sensation of *red*. Between these two wavelengths, separated by less than .0012 inches, are over 1000 distinguishable individual color energy levels.

Of course, our eyes do not allow us to selectively perceive and examine individual wavelengths in a mixture of many. We see the various wavelengths blended together into one "light." We call the general package of all visible wavelengths *white light*.

Light Spectrum. Most often, this light

ELECTROMAGNETIC RADIATION WAVELENGTHS

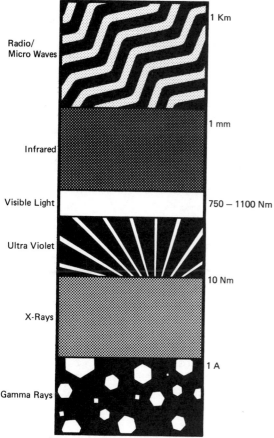

Radio/
Micro Waves

1 Km

Infrared

1 mm

Visible Light

750 – 1100 Nm

Ultra Violet

10 Nm

X-Rays

1 A

Gamma Rays

2-1 Electromagnetic radiation includes many wavelengths, with the visible portion taking up only a small portion of the range.

is a *continuous spectrum* containing wavelengths in various amounts of all those visible. Sunlight, household bulbs, and flash bulbs have such compositions. These sources do not usually contain equal amounts of each wavelength; they are either "bluer," or "redder" depending on the balance. We call such light sources, respectively, *cooler* or *warmer*.

Discontinuous spectra are lights that have a very limited number of wavelengths in their package. Fluorescent and other gas-

discharge bulbs contain some, but not all, sections of the visible wavelengths.

The relative "temperature" of a light may be measured and compared with that of other lights. *Kelvin temperature* is determined by adding 273 to the number of degrees centigrade to which a black metal radiator would have to be heated to take on a particular color. We use sophisticated devices to measure this Kelvin temperature, which will be a high number for bluer, cooler, light (5500K for daylight), and a lower number for warmer, redder light (1900K for candlelight).

Defining Color-Light Phenomena. There are a number of different physical processes that alter light, whether continuous or discontinuous, and thus result in color changes. A few simple definitions will help us understand the color-related activities that we observe daily. These events are so common that we would waste our whole day if we pondered their structure each time they were observed. However, by better understanding these processes, we may become more sensitive to them in our everyday encounters, with and without camera in hand.

Dispersion. This simply refers to the breaking up of wavelength groupings in a particular package of light. This alteration can result from a number of different events, each having its own effect on the light. The essential factor in dispersion is the separation of the light into its component parts.

Refraction. This is one common method of dispersing light. As light passes from one medium to another, its speed is altered. Light passing from air through glass is a good example. While in the glass, the light will be slowed down. This change of medium affects the shorter wavelengths (violet) more than the longer ones (red). When the light emerges from the glass, it will resume its normal speed, but the wavelengths will have

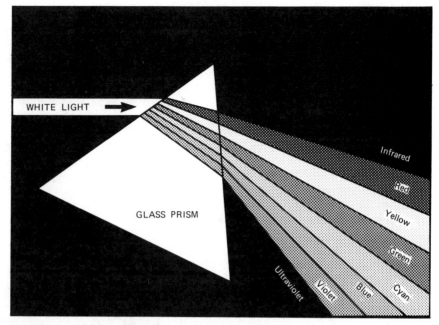

2-2 The continuous spectrum of white light is separated into its component wavelengths by dispersion, when it passes through a glass prism.

2-3 Those light rays which are not reflected, but which are slowed as they pass through a sheet of glass, will resume their speed once back in the air. The light waves have been somewhat separated by the effect of refraction.

REFRACTION

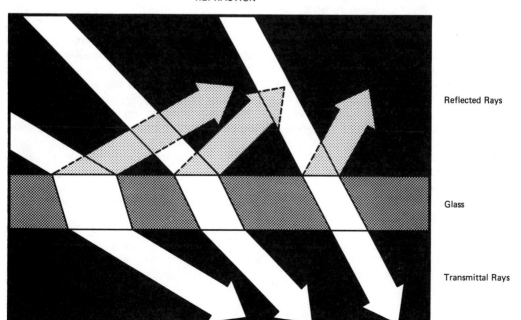

been separated more or less depending on the difference in effect of the air and glass. This effect is taken to extreme when a prism or droplets of water alter the light enough to produce a spectrum or rainbow. (See color-plate 9.)

Absorption. Absorption produces most of the color we perceive every day. When light strikes a material, it may penetrate it. If the material has no effect on the light, the wavelengths will pass completely through it. Such a material would be transparent. If, however, the material allows some of the light to pass through or reflect off of it but does not permit other parts of the light to do so, a change in the wavelength composition of the light will have occurred. This absorption of selected wavelengths gives the sensation of color to the material, associated with the wavelengths it does not affect. A simple example would be a green leaf. "White" light striking the leaf would all be absorbed, its energy transferred to the leaf, *except* for the substance in the leaf that reflects those wavelengths we associate with the color green. Those wavelengths will be reflected back from the leaf in many different directions. These reflected light rays are called *diffuse reflections*. We more often refer to them as the *color* of an object. If the light source illuminating the object contains only those wavelengths that will be absorbed by the material, the material will not reflect any light whatsoever. We call this absence of reflection *black*.

A surface, even if it is colored, may reflect light in such a manner that no wavelengths are absorbed. The "glare," or *specular reflection*, that results, comes from a mirror-like reflection of the light source itself. Except when it results from metal, this reflection is actually polarized light.

Scattering. This results from the deflection of wavelengths of light by minute particles, such as dust, which are as small or smaller than those wavelengths. This slight alteration of the path of light happens numer-

2-4 "Polarized light" causes glare reflections.

2-5 Elimination of glare by the use of a polarizing filter is an important creative decision.

ous times as sunlight passes through our atmosphere. Because of the small size of the particles, the deflection of wavelengths occurs more in the shorter waves (blue) than in the longer ones (red). The more of these particles the light must pass through, the more change in light color occurs. It is for this reason that the color of the sky, and sunlight, changes so dramatically from dawn till dusk. The blue sky, the bluish cast of objects seen at a great distance, and the reddish color of the sun and sky at times, are all a result of this process.

Diffraction. Diffraction results from the overlapping of wavelengths, which causes the separation of light. This phenome-

SCATTERING

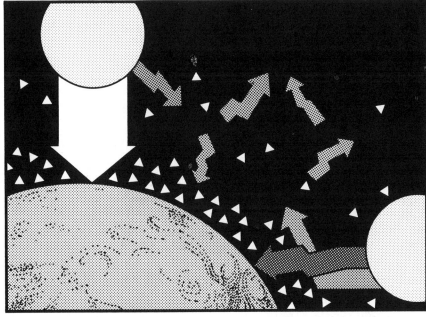

2-6 *Scattering* causes less blue light to reach us early and late in the day, when the sun's rays must pass through more atmosphere. At midday, light is scattered least, and appears bluest.

non can be brought about by an obstacle or very small aperture around which light rays bend, or by passing light through or reflecting it from a series of closely spaced parallel spaces or ridges. A commonly referred-to example of diffraction is the effect one perceives when looking sidewards at a black record album. The closely spaced grooves in the record not only produce sound, but cause "white" light to be reflected in such a manner that from any one angle only a limited number of wavelengths can be seen. The grooves in such a small space, break up the spectrum into separate waves, causing various single waves to either reinforce or cancel each other out.

Interference. Like diffraction, inter-

ference occurs when wavelengths from the same source interact, either canceling each other out or reinforcing each other. The effect on light is to either intensify or eliminate a particular color wavelength. This phenomenon usually results in a pattern of bands of lines of alternating light and dark, or colors. The myriad colors present in an oil slick or a soap bubble result from the interference of waves which reflect from both the surface and the base of the material. Acetate sleeves and glass negative carriers are double-faced materials familiar to photographers which may produce this effect. The colored bands are often referred to as *Newton rings*.

Fluorescence. This is the emission of radiation, usually as visible light, as a result of

DIFFRACTION

Blue Waves Red Waves

Light Reflecting Ridges

2-7 Light striking closely spaced ridges results in an overlapping of wavelengths, and separation of distinct color bands.

2-8 When wavelengths reflect from both the surface and base of a soap bubble, their cancellation and reinforcement results in a rainbow of colors.

INTERFERENCE

Reinforced
Blue Waves

Cancelled Red Waves

Soap Bubble

FLUORESCENCE

2-9 Atomic particles in fluorescent light tubes release light because of their absorption of energy from the charged poles.

the absorption by a material of energy from another source. "Black light" paints and dyes contain materials that release atomic particles when excited by ultraviolet light. Fluorescent lamps and neon signs surround us with light produced by a similar release of energy. The exchange of atomic particles which results in such light produces a very limited range of wavelengths.

A Theoretical Vocabulary

Color Description. Children learn their color names by remembering a fictitious character: ROY G. BIV. Red, orange, yellow, green, blue, indigo, and violet are more than just a mouthful for youngsters. The colors of the visible spectrum are arranged in that order, from longest wavelength to shortest.

Also, with the addition of a few more words—pink, brown, gray, black, and white—they comprise the total color vocabulary necessary to describe most of the visual sensations we feel the urge to talk about. Discussing color at all is a somewhat hazardous adventure, since we can't really know how another person is responding to a set of wavelengths we see as any of ROY's initials. In order to facilitate discussion and description of color on a higher-than-grade-school level, a number of systems for carefully analyzing and naming individual wavelengths have been developed. Out of all the research, a few simple terms have been evolved which can aid us in making an evaluation of a color and communicating that evaluation to others.

In speaking of color in these terms, we will be less than objective. Rather than basing our terms on measurable wavelength and

intensity, this vocabulary relates more to the common experience of color and light, and our felt need to relate its effect on us. These terms can be functional only if we assume that the light source is what would be commonly agreed on as "white." With every change in light will come changes in color balance.

Value or Brightness. These are terms used to describe the relative amount of light reflecting from a color, regardless of the color itself. "Light" and "dark" are two broad descriptions of this characteristic. A "dark" color is said to be "low in value," and a light shade of the same color is "high in value."

Hue. Hue indicates the light wavelength that is most dominant in the color source. This is the color itself, be it red, green, blue, or any of the individual colors that we can differentiate.

Saturation or Chroma. These indicate the narrowness or broadness of the band of wavelengths in any one hue. The narrower the band, the purer the color, the "higher the saturation." The wider the band, the more other wavelengths will neutralize the hue and tend to yield a perception of gray, and the "lower the saturation."

Making Color with Light. Painters

2-10 As red light, green light, and blue light overlap, they form white light at the center. These *additive primaries* also combine in pairs, to form the complementary color of the third.

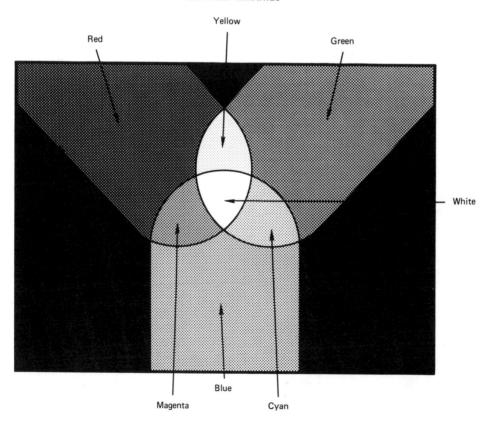

ADDITIVE PRIMARIES

SUBTRACTIVE PRIMARIES

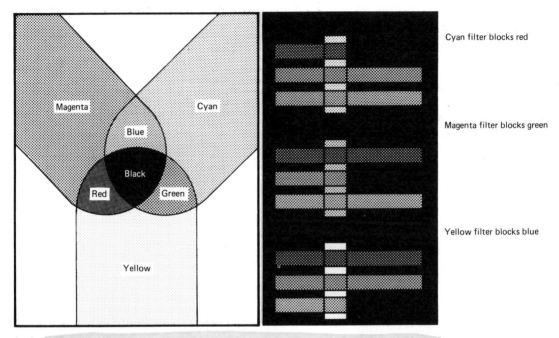

2-11 As yellow, cyan, and magenta filters overlap, each of these three *subtractive primaries* absorbs its complement from a white light source. Where all three overlap, no light passes through.

know that they can use various proportions of red, yellow, blue, black, and white pigments to produce mixtures whose absorptive qualities may be altered to produce any combination of value, hue, and saturation.

As photographers we must certainly be sensitive to the absorptive characteristics of our subject matter, but it is the characteristics of the light passing through our lenses and affecting film that concern us most. Two systems for production of the whole range of what we know as *color* are of prime interest to photographers. (See colorplate 1.)

The Additive Color Theory. This system produces color by beginning with no light, then adding different intensities and various combinations of red, green, or blue. These colors are known as the *additive primaries*. With equal amounts of all three, a

range from white through gradually darkening gray to black may be achieved simply by varying the light levels. This "neutral density" is all colors and no colors at the same time. Changing the proportions from equal amounts of the three colors results in shifts to any color desired.

The combination of equal amounts of any two primaries will form an important third color, which will be the *complement* of the remaining additive primary. The addition of complementary colors of light will form white light, if they both are intense enough. For example, red light plus blue light forms magenta light. Magenta is the complement of green. The addition of green light plus magenta light will make white light.

The Subtractive Color Theory. This system begins with a white light source. It

produces various hues, values, and saturations by eliminating portions of the white light mixture with filters of the colors cyan, magenta, and yellow. These pigment colors are each complements of an additive primary color. As filters, they subtract, or absorb, more or less of their complements from a white light mixture depending on their density.

When a magenta filter is placed over a white light source, it absorbs the color of its complement, green, and allows red and blue light to pass through. A cyan filter will absorb red, and a yellow filter will absorb blue, each allowing two of the additive primaries to pass through.

When any two subtractive primary filters are overlapped, they will absorb their complements and allow the third additive primary to pass through. When all three subtractive primary filters are overlapped, all three additive components of white light are absorbed. We will see a neutral density ranging from light gray to black, depending on the density of the filters. The color wheel in colorplate 1 indicates the methods by which additive and subtractive primary systems form color. Colors opposite each other on the wheel are complementary.

Both additive and subtractive color systems are widely used in photographic applications today. Although the vast majority of contemporary photography systems produce color by the filtering effect of the subtractive primaries, color television, Polaroid's Polachrome transparencies, and Sony's MAVICA still video camera all utilize the colored light blending system of the additive primaries.

Part II The Eye and Mind: Receptor and Interpreter

In Part I we examined two of the elements necessary for the experience of color and sight: a light source, either continuous or discontinuous, and a material that absorbs, re-flects, transmits, emits, or otherwise evidences light. The third necessity is twofold: a mechanism for both receiving and responding to light. For us, the eye and mind fulfill these functions (though some rabid photographers would say that their *camera* does this!).

The Eye

The eye is such an integral part of our existence that it hardly seems necessary to point out its importance. It is therefore astounding to most people to discover that science has not as yet determined the complete process by which we see! We know what the parts of the eye are, of course.

There are two protective outer shells of the eye. The *sclera* is the "white" of the eye, and the *cornea* the tough transparent covering over the *iris*, which is the circular shape that gives the eye its color. The iris consists of two sets of muscles which expand and contract around the aperture called the *pupil*. Light enters the eye through the pupil, the amount being controlled by the muscles of the iris, which allows more or less to pass through.

Behind the pupil and iris is the *lens*, which consists of clear fibrous tissue formed into two curved surfaces. The lens can alter its shape slightly, so that light from different distances passing through it is brought into focus on the *retina*, the interior rear surface of the eye. The retina holds rods and cones, which contain chemicals sensitive to light. It is the interaction of light with rods and cones, and the transmission of information about that interaction to the brain, which makes vision possible.

The *rods* are spindle-shaped cells, sensitive to small amounts of light. They are located outside the central portion, or *fovea*, of the retina and are used mostly for night vision. It is thought that they are insensitive to color. *Cones* are much larger cells, located in the fovea. These cells are thought to be sensitive to color.

THE EYE

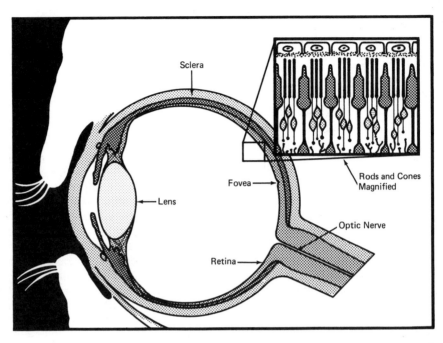

2-12 The eye, and its components.

Vision

When we "see" something, light passes through the cornea, pupil, and lens to the retina. There, a chemical change occurs in the rods and cones which is related to a breakdown of vitamin A. We must have vitamin A in order to see (eat those carrots!). This change is converted into signals which travel a complex chain of nerves to the occipital cortex of the brain. At that point, the information is translated into a cognition of "vision." It is not known, however, actually *how* we perceive light or color. The chemical and neurological reactions have yet to be deciphered.

Theories of Vision. Two theories of color vision prevail in scientific circles. The Young/Helmholtz theory, first espoused by Thomas Young in 1802, contends that there are really three different cones, each sensitive to one of the three additive primary colors, red, green, or blue. The varying of amounts and intensities of these colors, we know, can be made to produce for us the whole range of visible light. The problem with this theory is that it does not adequately explain color-sense deficiency, colored afterimages, colors associated with physical pressure on the eye, or the sensation of black.

Edwin Land's theory of color vision was developed during his research in instant color photography. The Land theory postulates that color visual sensation is formed by the brain's interpretation of a set of information about the wavelengths of light striking the retina from any single point. Rather than being receptors of only red, green, or blue, cones are thought to be tools for comparison of long and short wavelengths. From an anal-

ysis of these measurements, it is assumed, a determination as to color is produced. Land's theory would explain some of the deficiencies in Young's, but as yet neither can be proven correct.

Perception. Regardless of which theory of *how* we see is correct, there are certain commonly observed results of vision which impact dramatically on our reaction to the world around us. We cannot know whether colors are seen by all of us in the same way; in fact, it is likely that they are not. The effects of color and light on anyone are completely dependent on his or her physical and psychological state at the time. Color and light are also interpreted by each person on the basis of preferences, memories, and experiences. There are, however, a few common observable effects of vision and perception. The better you understand the various modes of vision that affect your interpretation of the world around you, the better you will be able to perceive photographic possibilities resulting from these common experiences.

Color and Brightness Constancy. This phenomenon maintains our perception that a "red" apple remains red whether it is viewed under tungsten, noonday, or early morning light. We ignore color changes that result from different illuminations of a *familiar* object, person, or place. A photograph of a person standing under a red beach umbrella would look terribly unnatural if we were to print it as the film objectively recorded the scene. The overall red color of the light would be ignored in our visual perception, and its record in the print would be an unpleasant revelation. In the same manner, we accommodate for increases and decreases in illumination while maintaining a perception of brightness in a familiar object or scene. We draw on previous encounters with the thing seen, rather than solely its brightness at the time it is observed, to evaluate its brightness.

Constancy requires a relatively continuous spectrum light source and familiar subject matter.

Brightness Adaptation. This relates somewhat to constancy, in that we are extending our vision beyond that which is before us. Constancy relates to previous experiences with a tone or chrome. Adaptation relates to the ability of the eye and mind to adjust for the brightness of a scene and to present us with a rapidly changing vision as a result. This phenomenon is familiar to any photographer who has ever walked into a darkroom to process a roll of film: lights off, darkness descends, but . . . not for long! The room which seemed so dark at the outset is gradually transformed by tiny light leaks into a room light enough for us to see the light-sensitive emulsion. Of course the room did not really get brighter, but our vision gradually adapted to the darkened room so that it seemed as if it did. This urge to adapt to and "level off" high and low brightnesses should make us wary when we evaluate a scene for its pictorial and exposure qualities. As light gradually increases and dims in the scene, our adaptation will cause it to seem to change less than it actually does.

Simultaneous Contrast. This effect relates both to colors and to shades of gray. Differences in tones or chromes of shapes or objects in a scene or picture are emphasized when they are juxtaposed. Darks appear darker, and lights appear lighter, when adjacent to their opposites than they would if set in an array of tones closer to their own. Colored objects placed next to objects colored in their complement may actually seem to vibrate as the eye attempts to focus on both. A color's hue and brightness may appear altered if you simply change the colors around it.

Afterimage. When we observe and evaluate a particular color, one of the ingre-

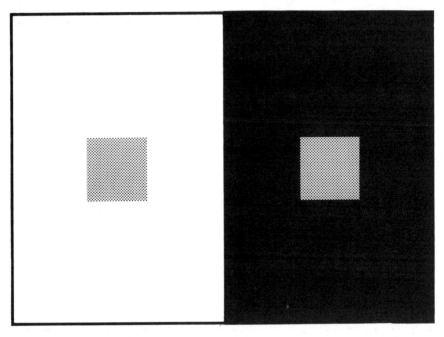

2-13 Simultaneous contrast. Note the apparent changes in value which occur in the same dot pattern when it is juxtaposed with black and white.

dients in determining our response to it is the color we focused on immediately before the new one. A color seen in a sequence will always be affected by the "afterimage" of the color seen immediately before it. This spillover is greater the longer a previous color has been observed. The afterimage color is the *complement* of the color previously focused on. For example, if you focus on a red-colored object for about 30 seconds, then fix your gaze on a white paper, you will see the object's image in its complementary color, cyan.

Part III A Common Psychology of Color and Light

Light and color give form to perception. Without illumination, there is nothing but blackness. In the mind of the sensitive pho-

tographer, however, there is pictorial appeal in both the darkest of blacks and brightest of whites. The infinite modulations of shades of gray and varieties of color, and individual responses to those changes, are what make photography such a unique medium of expression.

Light

Light communicates shape and form. Its angle and intensity, and resulting shadow, give visual clues to both the outline and volume of objects. An emphasis on three- or two-dimensional aspects of a thing, directed by purposeful use of light, can result in striking insights into both the thing *and* the photographer. Shadows and silhouettes can be emphasized as literal shapes with content, meaning, and substance. These clues can

2-14 The ever changing pattern of shadow and light provide new subject matter at a moment's notice.

lead a viewer to "correct" or "incorrect" interpretations, depending on the reaction sought by the photographer.

The ability of the photographer to describe *texture* depends not only on the accuracy of a lens, but on the description made possible by light. The tactile sensation of an object, evoked purely by lighting, when seen in a glossy print, can be quite astounding.

Light not only can alter the representation of a scene, but can become a pictorial statement in itself. Shafts of light as metaphors for emotion, the light airy mood struck by an image whose overall tone is bright, and the more somber mood of an object that is generally dark all are effective because of the cultural meanings of light we absorb throughout life.

Whether we use light solely as illuminator, or as subject matter itself, the wide variety of approaches to its function must be narrowed and tailored in response to each new pictorial situation. There are no light "formulas" which can be easily applied to photogra-

phy, without a stale taste emerging. An awareness of light in its many roles is crucial to honest photography.

Color

As with light, color's function can be defined to such a degree that it ceases to have any meaning. Colors can be coordinated to make a picture macho or feminine, warm or cool, loud or soft, boring or exciting, tender or rough. Being aware of common color relationships, and commonly understood meaning, will help you recognize when it is appropriate to either conform to, or break, the "rules."

Color Wheel Definitions. The color wheel is arrayed in such a manner that certain color relationships may be observed. Colors near each other on the wheel are *harmonious*, having minimum color contrast. Colors opposite each other are *complements* and will produce maximum color contrast when juxtaposed.

Warm and active colors (reds, oranges, yellows, etc.) are arrayed opposite cool and passive colors (blue, green, violet, etc.). Generally speaking, the cooler colors will seem to recede from, and the warmer colors tend to move toward, the viewer. We can take advantage of this effect by placing cooler colors in the background and warmer colors in the foreground to increase the sense of depth, or just the opposite for a more jarring effect.

The Mood of Color. Using color to impart a mood to the viewer depends on the viewer's understanding the communication. The phrases "feeling blue," "seeing red," or "he's yellow" result from a commonly understood set of associations with these colors. While any individual's response to a color will be very personal, certain common color meanings can be taken advantage of.

Red. Danger, blood, and STOP all come quickly to mind in an association test with this color. It is the most aggressive, hottest, most violent, and most attractive of the colors.

Orange. Warmth, fire, halloween, and an attraction almost as great as that of red. It too seems to advance toward the viewer.

Yellow. Sun, cowardice, disease, and similar contrasting meanings make this a difficult color to work with. Cheerfulness and jaundice are evoked by the same hue, in different contexts.

Green. Nature, envy, calm are all evoked by this first of the cool colors. It can symbolize renewal, peace, and calm in a landscape, but can look sickly and disgusting when mixed with yellow. It's horrifying when it colors human skin.

Blue. Tranquility, coolness, and melancholy can be imputed by use of this color. It can imply calm and quiet, or an icy temperament.

Indigo and Violet. Death, rebirth, penitence, and other sometimes solemn and sometimes joyful activities and emotions are implied by these colors. Nobility and grandeur are also possible.

White. Clean, pure, virginal, unblemished, and cheerful. The Western world wears this color to weddings, the Eastern world to funerals.

Black. They didn't call it the Black Death for nothing! However, doom and destruction are not the only possibilities associated with this color. Sophistication, elegance, and exotic mystery may also be evoked.

Gray. Calm, dignified, objective, ambiguous, and floating from joy to defeat as it becomes darker.

Part IV Light Source Effect on Color

Daylight and the Weather. Whether your photographic concerns relate to portraiture, landscape, macro studies, documentary, interpretive, performance, or abstraction, if you do not use artificial lights, the content of your pictures will be indelibly stamped with meaning imposed by the ambient, natural light.

For reasons already mentioned, it is our natural tendency to somewhat ignore subtle, and even dramatic, changes in natural lighting. There is a very practical reason for this, known as survival. If we spent all our time analyzing the constantly changing flow of light and color, we would be quite insane in a short period of time. However, when camera is in hand, it pays to go a bit daft. A heightened sensitivity to your environment and to the effects of weather, time of day, and season of the year on the quality of light illuminating the scene you are photographing is crucial for sensitive work. (You should be equally aware of the effects of artificial light sources as they dominate, blend with, or supplement the natural illumination. We will discuss this soon.)

Twenty-Four Hours of Light. The "light of day" is as varied in its intensities, moods, and meanings as anything that is constantly changing. From before the sun's rise, through its daily inexorable movement across the sky, until well beyond its disappearance, light alters its character and effect in a multitude of ways. Just take a few minutes to watch a shadow move, if you don't think that relationships defined by daylight exist only momentarily. Of course, there are more gradual, subtle, changes in light. Let's examine these changes over a typical day.

Predawn. Get up *early!* There is an abundance of cool, monotone, quiet, gentle light. The absence of directional shadows

provides a low-contrast, low-color, muted at-
mosphere. The lack of color evokes a sense
of stillness and calm that is unique. (See col-
orplate 6.)

Dawn. Shafts of warm, golden-red
sunlight stream in long, bold shapes. The
warmth imparted to spaces and shapes that
are illuminated is in sharp contrast to the still-
cool blue, deep shadows. The strong direc-
tional light seems to slice through space and
crash into the areas it strikes. (See colorplate
7.)

Morning. Warm and *clear*. After the
mist of early morning and the silhouettes
formed by dawn have disappeared, the am-
ber-yellow light of this time imparts a crisp
and clean delineation of life, textures, shapes,
and forms.

Midday. Piercing the veil! The sun at
midday is at its most intense, its whitest, and
its harshest. Colors are at what we perceive
to be their "truest," with the overhead sun
producing a stark overall contrast. This is es-
pecially true in summer, when the sun is at its
highest in the sky. (See colorplate 8.)

Afternoon. Is it morning again? In
many respects the light echoes some of its

2-16 Try to find a new perspective, both literally and
emotionally, from which to view familiar subject matter,
such as a sunset.

earlier emotions and alterations, as it gradu-
ally lowers toward the horizon. Shadows
lengthen; volume, texture, and depth of
space increase. Colors warm, and the envi-
ronment becomes more and more illumi-
nated from the west.

Sunset. Calendar photographers, get
ready! This is a time when sentiments and
emotions are evoked by the rich redness of
light, the long slowing shafts and cooling
shadows, and the symbolism built up over
eternity. (See colorplate 18.)

Twilight. On the edge of darkness,
just as during predawn, the palette of colors
on land and in the sky changes with a speed
that is awesome. The orange glow of sunset
can shift to a wild variety of violets, pinks, and
magentas, as unique combinations of light
and atmosphere intermingle.

Night. Color! Long exposures, failure
of reciprocity shifting film color response,

2-15 The hard, direct light of midday may be used to
heighten contrasts of shape, texture, and tone.

light from the moon and street lamps, alterations of atmosphere, all make this a wonderful time for the photographer willing to experiment. The camera will record color and light that we do not realize exists, and that often doesn't exist in the form in which it is recorded. (See colorplate 19.)

The Weather. Cold! Hot! Rainy! Foggy! Snowy! Windy! "Adverse" weather conditions are almost always excellent conditions for making photographs. Of course, you should take some common sense steps to protect both you and your camera from damage. However, don't limit your explorations through photography to fair weather alone.

Rain. A dark, middle, or light gray sky, coupled with the blurring effect of the thousands of droplets between you and the scene, will greatly affect your color photographs on rainy days. A shift in overall color toward blue-gray, a blending of shapes and colors seen through the rain, and reflections from wet pavement are all available for your use. Hot colors in such an atmosphere will leap toward the viewer, yielding a great three-dimensional effect. (See colorplate 16.)

Fog and Mist. The numerous forms of fog, from the thickest "pea soup" to the lightest misting in drizzle, give ample opportunity for creative expression and exploration. The mystery and meaning of the fog itself, coupled with the manner in which trees, buildings, and other elements in the environment seem altered by it, offer a chance for you to impose your own photographic interpretation as well. Large, well-defined shapes in the foreground may be used to contrast with those blending with fog in the background, to give a dramatic description of space. Look also for moments when lights and objects seem suddenly to pierce the fog with shifts of a breeze. (See colorplate 17.)

Snow. When the sun is out and snow blankets the environment, don't complain be-

2-17 The powerful forces evident during inclement weather may be used to dramatically alter the normal context of a scene.

2-18 The mist between the foreground and distant objects, may be used to give a strong indication of distance.

cause there's "no color." Any "colors" other than the white stuff will stand out now in striking contrast. Within the snow itself there are terrific gradations, not only of brightness but of color as well. The variations of light color throughout the day will "paint" the snow in a variety of hues. The icy blueness of shadows may be put to good use as well.

When it is snowing, grab a cup of hot chocolate and get outside! Be careful not to underexpose your film, and look for subject matter for which the curtain of white atmosphere will form a revelation rather than a cover. Look for snowfall at night, early, or late in the day, when color casts from both daylight and street lights, neon, and home lights, filter through the powdery haze.

Artificial Light

As a photographer using directed artificial lights, you take on a weighty responsibility. While photographers working with natural light may make excuses for their lack of light control, you may not. The photograph's success or failure will be based almost totally on your ability to manipulate your light source.

Your main decision is to determine where in the spectrum, from "normal" to "obviously not normal," you want your lighting statement to be. The more normal or natural the lighting, the more a viewer will focus on the objects or scene in the picture. As your manipulation of light becomes more and more "abnormal," the light's role as subject matter will increase. Taking it to extremes,

2-19 Artificial light, when used as the electronic strobe was in this photograph of a rain-hat-covered head, may transcend illumination to the point where it becomes the subject of the photograph as well.

you can make your pictures seem to be more about light than about the things that were illuminated by it.

Color effects of artificial light sources are covered in chapter 3.

3 COLOR FILM

A thorough understanding of how we perceive light, in a physical, psychological, and emotional sense, will make you a more successful photographer. Your awareness of color changes in a scene and their bearing on the value of your photographs is critical for sensitive communication.

We now must couple the review of color and light in chapter 2, with the specifics of our medium. The process of translating the world of color into a photographic image begins with the exposure and development of our film. In order to understand the processes for production of color negatives and transparencies, and prints for that matter, a solid understanding of the additive and subtractive theories of light is essential.

Additive and Subtractive Light Theories: *A Review*

Remember that "white" light may be viewed as simply a combination of red, green, and blue light: the *additive primary* colors. Any color at all may be produced in various hues, saturations, and brightnesses by varying the proportions of these three colors of light. Re-

member also that various colors of light may be produced by a filtering system which absorbs portions of the white light mixture. The filter colors we will be most concerned with are cyan, magenta, and yellow: the *subtractive primary* colors. Each of these subtractive primary colors will absorb more or less of their additive primary complements, depending on their density. Each subtractive primary filter both blocks its complement *and* allows the remaining two additive primaries to pass through, or reflect. For example, a yellow grapefruit seems yellow because it absorbs its complement, blue light, and allows red and green (which we see mixed as yellow) to reflect.

Color Film Structure and Process

Color film may be one of two types, *color reversal* film or *color negative* film. Color *reversal* film, or color slide film, as it is more commonly known, produces a positive transparency whose colors are the same as those of the original scene. Reversal film is available in a number of sizes, in both roll and

sheet. Since a finished picture is produced after development, any manipulations of color balance or image tone must be made during exposure. Reversal film is especially sensitive to changes in exposure, and under- or overexposures of more than one-half stop may alter the picture dramatically.

Color *negative* film is used to produce a picture on film whose colors and tonal scale are the opposite of those that appeared in the original scene. Colors will be rendered in their complements (a red apple would look cyan in the negative), and light areas will appear dark. Negatives are almost always produced as an intermediate step in the process of making a color print. Like reversal film, negative film is available in a number of sizes. It is less dramatically altered by changes in exposure. Overexposures of up to two stops, and underexposures of up to one stop, may be compensated for in printing.

Most color balance problems that affect the negative may also be eliminated to some extent by manipulations in printmaking.

New color films are being introduced almost daily. Kodak, Fuji, 3M, Agfa, and Ilford have been joined by many new names in the business of film manufacture. There *are* differences in grain, sharpness, and color balance between any two different films, even by the same manufacturer. Once you have become familiar with a few different types of negative and reversal films, try other kinds for comparison of effects. You may find one film that suits your approach to portraiture, another more suitable for expressing your landscape ideas, and so on. Picking the right film for a particular situation can be done only if you have made an effort to experiment with new emulsions. You will find some films to be more accurate in their color rendition, and some that lean to warmer or cooler interpre-

3-1 Whether reversal or negative, most contemporary color films have a similar structure.

CROSS SECTION OF CONTEMPORARY COLOR FILM

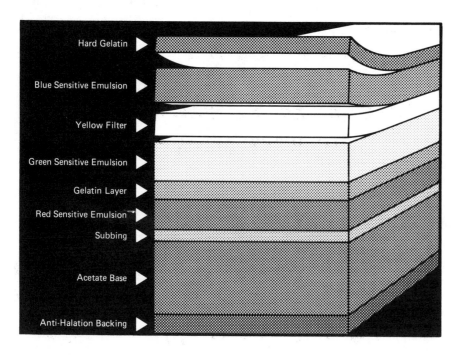

Hard Gelatin ▶

Blue Sensitive Emulsion ▶

Yellow Filter ▶

Green Sensitive Emulsion ▶

Gelatin Layer ▶

Red Sensitive Emulsion ▶

Subbing ▶

Acetate Base ▶

Anti-Halation Backing ▶

tations. Some films will accept a greater range of exposure modifications than others, and the grain structure and range of contrast will be different as well. The choice of which film, for which process, for which situation, for *you*, is a personal one of great importance.

A Basic Process Outline. Negatives and transparencies undergo similar chemical changes during development. Whatever the material being processed, the picture is first developed as a *black-and-white* negative.

Basically, color film is made up of three layers of emulsion supported by an acetate base. Each layer of the film is sensitive to only one of the three additive primaries: the top layer to blue light, the middle layer to green light, and the bottom layer to red light. The varying sensitivities of these three layers allow the photographer to "separate" a scene into its three additive light components in a single exposure. During the development process, each layer produces a different black-and-white negative, each corresponding to the amount of light present in the scene to which it was sensitive. In a subsequent step, the developer oxidizes and then combines with chemical couplers in the emulsion to form dyes. The formation of magenta dye in the green-sensitive layer, yellow dye in the blue-sensitive layer, and cyan dye in the red-sensitive layer, and the removal of all silver from each layer, complete the process of making a color picture in film.

Processing Color Negatives and Transparencies

The processes that determine whether a picture will be a color transparency or a color negative involve combining a particular film with an appropriate chemical system. Different films and chemistries are available from a number of different manufacturers, but the effects of exposure and development are all similar.

Color Negatives. The finished color negative holds an image of the scene, recorded in colors *opposite* those present at the time of exposure. A red apple will appear cyan, a yellow ball will appear blue, etc. While color negative films differ in film speed, light color balance, size, and manufacturer, they are almost all based on similar principles of exposure and development.

The characteristic brownish-orange cast of a color negative is caused by the chemical couplers which produce magenta and cyan dyes. These couplers are *colored* during manufacture and are not removed from their emulsions during the development processes. Their function is to correct the imperfections in color balance caused by the inherent impurity of all magenta and cyan dyes. This process of correction is commonly known as *masking*.

Chemistry for processing color negatives is available from a number of manufacturers, each having its own special set of instructions concerning development times and temperatures. Most color negative films available today are meant to be processed in "C-41" type chemistry, but don't assume that the film you want to process is; read the film canister! Eastman Kodak's *Flexicolor Process C-41*, *Unicolor K-2*, and *Beseler CN-2*, when used with films marked for C-41 process, will produce negatives through a process similar to that described in figure 3.2.

The differences among the various chemical systems are mainly in the area of processing and packaging. Some systems involve very high temperatures and brief development times, which require more critical control of the process. Others are geared to lower temperatures and longer times. Sets of processing chemistry are also packaged in different forms. The choice of whether to purchase chemistry in powdered or liquid form is usually based on whether you prefer mixing just enough for a few process runs, or larger amounts. Since storage time for all color chemistry is limited, this is a very important consideration.

NEGATIVE FILM, FROM EXPOSURE THROUGH DEVELOPMENT

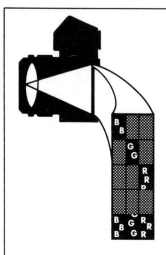

3.2A During *exposure* in the camera, light reflected from the subject affects one or more of the three color-sensitive layers of emulsion, forming a latent image. The scene is actually separated into three distinct overlapping pictures, corresponding to the amount of red, green, and blue present in the scene. The emulsion layers do not move during development, and the three pictures remain in perfect registration.

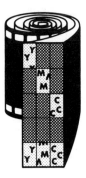

3.2B During *development*, the three latent images emerge as visible black-and-white negatives. At the same time, the oxidation of the developer causes chemical couplers in each emulsion layer to produce a dye. The dye produced in each layer is the complement of the color to which that layer was sensitive. The red-sensitive layer produces cyan, the green-sensitive layer produces magenta, and the blue-sensitive layer produces yellow. At this stage, the film contains both silver and color-dye negative pictures.

3.2C The next step is *bleach-fix*, or *blix* for short, which removes both the metallic silver produced by development, and the silver halide crystals left undeveloped.

3.2D The final chemical process is a formaldehyde-based *stabilizer*, which helps protect the picture-bearing dye layers from fading or discoloration. The stabilizer also contains a wetting agent which aids in even film drying without water spots.

REVERSAL FILM, FROM EXPOSURE THROUGH DEVELOPMENT

3.3A During exposure, the three layers of emulsion are affected by the colors of light in the scene to which they are sensitive, forming a latent image. Just as with exposure of the negative, the scene is "separated" into three distinct overlapping images.

3.3B The *first developer* converts the latent image into a silver-based black-and-white negative. No dyes are produced at this stage.

3.3C Immersion of film in the *color developer* instantly activates the reversal agents, which cause two things to happen in tandem: the development of any remaining silver halides and the production of subtractive primary dyes in any of the emulsion layers being developed. The dye layers produced during this positive image development will form the final picture.

3.3D At this point, the film contains metallic silver in all layers of the emulsion, and color dyes in many places. It looks completely black. In order to be able to see the dye-positive picture, you must first *bleach* the film. The bleach converts all silver into silver halide crystals.
The *fixer* next removes all the silver halides from the film, leaving only the dye-positive picture. With Rapid E-6, bleach and fix are combined in one step, *blix*.

3.3E A *water wash* removes any remaining fixer, followed next by a *stabilizer*, which allows the film to dry evenly and protects it from dye-fading or discoloration. Stabilizer is an optional step with Rapid E-6.

Color Transparencies. Color transparencies are made with color reversal film and an appropriate chemical development process.

Like color negative film, color reversal film contains three layers of emulsion, each sensitive to one of the three additive primaries. A major difference between negative and reversal film is that none of the color couplers that produce dyes during development of the transparency is colored. The brownish-yellow cast of the negative would not be appropriate for the transparency. The other most obvious difference between the two films is that, after processing, a color reversal transparency is a positive rather than a negative image.

After development, a *reversal bath* couples any silver halides left in the emulsion with a "reversal agent." This chemical will cause the silver halides to develop, creating a positive black-and-white image, when subjected to the *color developer*. In some chemistry systems, such as Unicolor's Rapid E-6, reversal bath and color developer steps are combined.

A *stop bath* neutralizes the alkaline color developer and aids in its removal during the next step, a *water rinse*. This step is eliminated when you are using Rapid E-6.

Into the Darkroom with Film

In this section we will move step by step through two different film development processes, one for negatives and one for transparencies. To begin with, you should follow the process steps recommended by the manufacturer. After you become familar with them, and the results they produce, you may like to experiment with over- and underdevelopment, alteration of temperatures, and other modifications. The processes outlined here are typical of their chemical types, so even if you use a system from another manufacturer, the procedures should still be similar enough to be of benefit to you.

Before and After Processing. Whether you are processing film "straight" or "manipulated," your darkroom activities should always be accomplished with *cleanliness* and *consistency*. Without clean equipment and regular, thorough rinses of film and tanks during processing, contamination of chemistry is bound to occur. Such contamination will make predictable results impossible and could ruin your film. Whether you are following the manufacturer's instructions or experimenting with an altered development, be absolutely consistent in your processing. You won't be able to repeat your results unless you carefully monitor temperature, time, and agitation.

Although the darkroom and equipment you have been using for black-and-white film processing will certainly function with color work, there are three considerations which may alter your work habits in the transition. *Temperature* is crucial in most color processes, and your control of it will greatly affect the quality of your film. *Ventilation*, which may have been a nicety in black-and-white work, is a necessity for color for your own safety. *Developing tanks*, and reels, should be made of stainless steel rather than plastic. Although these are a bit more difficult to load at first, the metal can be brought to processing temperature more rapidly, it is more durable, and it is easier to clean than plastic. No matter which film or development process you are using, there are certain steps which are common to both. (Figure 3.4)

Whether you have processed a roll of negatives or transparencies, your next task is to find an initial storage system for them. If you will be printing your transparencies and there is no need to have them projected immediately, file them exactly as you do your negatives, in storage pages. (Figure 3.9)

These pages are made of transparent plastic or acetate and will keep your film flat and protected from dust and moisture. The pages are usually hole-punched for insertion in a ring binder for convenient holding. They can be easily numbered for accurate record keeping. One of the best features of the

PROCEDURES COMMON TO VARIOUS FILM DEVELOPMENT PROCESSES

3-4A-B Color film development requires strict control of chemical and wash temperatures. You should use either a water bath, or temperature controller to maintain proper processing temperatures.

3-4C Gather a pair of scissors, rubber gloves, thermometer, bottle opener, your development chemistry, an accurate timer, a stainless steel tank and reels, and your exposed film. Open the tank and place it and the reels on a clean countertop where you may find them easily in the dark. You should start heating your chemistry *before* you load film into the tank.

3-4D *Turn off the lights in your darkroom.* Open the film cassette on its flatter end, with a bottle opener.

3-4E Trim the tongue from the film, making as square a cut as possible.

3-4F Hold the reel so the spiral grooves turn in a clockwise (for you right-handers) or counter clockwise (for you lefties) manner.

3-4G Bowing the film with slight pressure on both sprocket-hole sides, insert the end into the clip at reel center. Turn the reel counterclockwise (righties only!) so that the film is pulled into the grooves. Never push or force the film in.

3-4H When you reach the end of the reel, cut the spool off and finish loading.

3-4I Even if both reels do not contain film, both should be placed in the tank (loaded reel first) for proper agitation.

3-4J-K After the cover is on, *you may turn on the lights*. Follow the times and temperatures for the process you have selected. Agitation recommended during development, should consist of a complete reversal, up-side down and back again once every second. Be sure to rap the tank sharply on the sink or counter during initial agitation to remove air bubbles.

3-4L After processing, hang film to dry, using either metal or wooden clips.

3-4M Your bathroom is probably the cleanest and least dusty room in the house. Dry your film there.

Table 3.1 Summary of Steps for Negative Processing Using Kodak Flexicolor Chemistry at 100°F. (37.8°C.)

PROCESSING STEP	TIME IN MINUTES	TEMPERATURE	ELAPSED TIME
Developer	3'15"	$100 \pm \frac{1}{4}$	3'15"
Bleach	6'30"	75-105	9'45"
Wash	3'15"	75-105	13'
Fixer	6'30"	75-105	19'30"
Wash	3'15"	75-105	22'45"
Stabilizer	1'30"	75-105	24'15"
Air-dry as necessary			

A 10-second drain is counted as part of each processing step.
Agitation: For each step, 30 seconds initially, then: developer, rest 13 seconds, agitate 2 seconds; bleach and fixer, rest 25 seconds, agitate 5 seconds; stabilizer, no agitation.

Courtesy Eastman Kodak Co.

NEGATIVE PROCESSING STEPS. For this process, we will use Kodak VR 100 film, with Kodak Flexicolor chemistry.

3-5 *Kodak Flexicolor Process for Color Negatives.* Gather the needed materials. Follow instructions for mixing chemistry, using distilled rather than tap water. Heat chemistry to temperature, load film onto reels and place in tank. Put rubber gloves on, and check ventilation.

3-6A Check chemistry temperature.

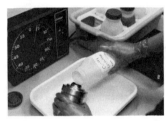

3-6B Set timer for 3′15″, start timer while you pour in developer, rap tank, and agitate according to instructions.

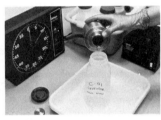

3-6C Ten seconds before time has ended, begin pouring developer from tank. Save for reuse.

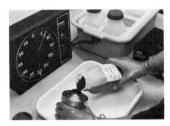

3-6D Set timer for 6′30″, start timer while you pour in bleach, rap tank, and agitate according to instructions.

3-6E Ten seconds before time has ended, begin pouring bleach from tank. Save for reuse.

3-6F Set timer for 3′15″, check water temperature, then wash film *with tank cover on.*

3-6G Set timer for 6′30″, start timer while you pour in fixer, rap tank, and agitate according to instructions.

3-6H Ten seconds before time has ended, begin pouring fixer from tank. Save for reuse.

3-6I Set timer for 3′15″, start timer, and wash film. The cover may be removed.

3-6J Drain tank, then set timer for 1'30", and start timer while you pour in stabilizer. Do not agitate.

3-6K Ten seconds before time has ended, begin pouring stabilizer from tank. Save for reuse.

3-6L Remove film from reel and hang to dry.

Table 3.2 Storage Time at Room Temperature (60–80°F.) of Working Strength Solutions

SOLUTIONS	FULL, TIGHTLY CLOSED BOTTLES
Developer	6 weeks
Bleach	Indefinitely
Fixer	8 weeks

Courtesy Eastman Kodak Co.

Table 3.3 Capacity

Each pint will process eight rolls of 35mm, 36-exposure, Kodak VR negative film. The developer time only must be changed after each set of two rolls of film has been proceed, to compensate for deterioration of developer.

DEVELOPMENT TIME CHANGES

Rolls 1 and 2 Normal	Rolls 5 and 6 Normal + 13 seconds
Rolls 3 and 4 Normal + 8 seconds	Rolls 7 and 8 Normal + 19 seconds

Table 3.4 Troubleshooting for Film Processed in Flexicolor Chemistry

PROBLEM	POSSIBLE CAUSE
Dark crescent shapes on film	Film was bent or kinked during loading on reel before development.
Negatives too dark	Overexposure.
	Too much development time.
	Too much agitation.
	Too high a temperature for developer.
Streaks or blotches	Air bubbles on emulsion because of inadequate agitation.
	Film was wet by water or chemicals before development.
	Water spots from drying.
Negatives too light	Underexposure.
	Too little development time.
	Too little agitation.
	Too low a temperature for developer.
	Too little developer in tank.
Odd color balance	Contamination of solutions.

Courtesy Eastman Kodak Co.

Table 3.5 Summary of Steps for Reversal Processing Using Unicolor Rapid E-6 Chemicals at 100°F. (37.8°C.)

PROCESSING STEP	TIME IN MINUTES	TEMPERATURE	ELAPSED TIME
First developer	6'30"	100 ± ¼	6'30"
Water rinse	2'	92-102	8'30"
Color developer	6'	99-101	14'30"
Water rinse	2'	92-102	16'30"
Blix	6'	92-102	22'30"
Water rinse	2'	92-102	24'30"
Air-dry as necessary			

A 10-second drain time is counted as part of each processing step.
Agitation: For each step, 15 seconds initially, then 2 seconds each 15 seconds thereafter.

Courtesy Unicolor Photo Systems.

REVERSAL PROCESSING STEPS. For this process, we will use Unicolor's Rapid E-6 process, with Kodak Ektachrome 64 film.

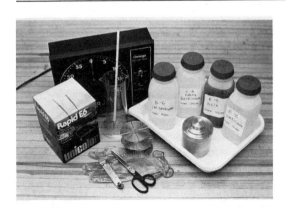

3-7 *Unicolor Rapid E-6 Process.* Gather the necessary materials. Follow instructions for mixing chemistry, using distilled rather than tap water. Heat chemistry to temperature, load film onto reels and place in tank. Put rubber gloves on, and check ventilation.

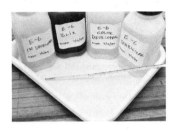

3-8A Check chemistry temperature.

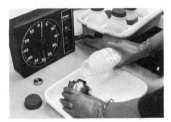

3-8B Set timer for 6'30", start timer while you pour in first developer, rap tank, and agitate according to instructions.

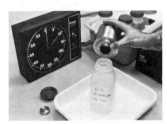

3-8C Ten seconds before time has ended, begin pouring first developer from tank. Save for reuse.

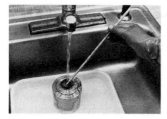

3-8D Set timer for 2', start timer, and wash film with cover on. Drain.

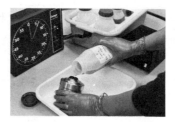

3-8E Set timer for 6', start timer, while you pour in color developer, rap tank, and agitate according to instructions.

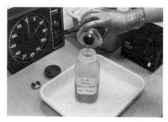

3-8F Ten seconds before time has ended, begin pouring color developer from tank. Save for reuse.

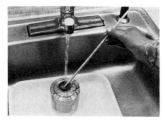

3-8G Set timer for 2', start timer, and wash film with cover on. Drain.

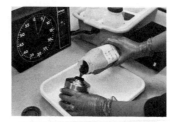

3-8H Set timer for 6', start timer while you pour in blix, rap tank, and agitate according to instructions.

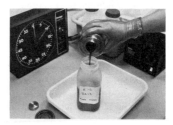

3-8I Ten seconds before time has ended, begin pouring blix from tank. Save for reuse.

3-8J Set timer for 2', start timer, wash film.

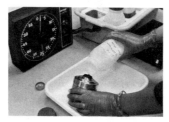

3-8K A stabilizer bath is optional for this process. If you like, you may stabilize the film in a bath made from 1000ml of Kodak Photo Flo mixed with 10ml formaldehyde, for one minute. In either case, at the end of rinse or stabilizer, hang film to dry.

pages is your ability to make a contact sheet of the film without ever touching the film itself.

If you find it necessary to mount your transparencies for projection, you have a choice of *heat-seal* or *plastic-insertion* systems. The advantage of the heat-seal cardboard mounts is the low price per mount. The disadvantages are many, among them: the possibility of damage to the transparency during mounting; the ease with which the mount may be bent; the extra time and ne-

Table 3.6 Storage Time at Room Temperature (60–80°F.) of Working Strength Solutions

SOLUTION	FULL, TIGHTLY STOPPERED BOTTLES	USED SOLUTIONS
First developer	8 weeks	4 weeks
Color developer	12 weeks	8 weeks
Blix	24 weeks	24 weeks

CAPACITY

Each quart of working solution will process eight rolls of 36-exposure, 35mm E-6 process reversal film. After the first four rolls have been processed, the remaining four rolls must be immersed in the first developer 30 seconds longer than normal, to compensate for deterioration of developer.

Courtesy Unicolor Photo Systems.

Table 3.7 Troubleshooting for Film Processed in Unicolor Rapid E-6 Chemistry

PROBLEM	POSSIBLE CAUSE
Light picture	Overexposure in the camera.
	First developer too warm.
	First developer time too long.
	Excessive agitation in first developer.
Dark picture	Underexposure in the camera.
	First developer too cool.
	First developer time too short.
	First developer exhausted.
	Insufficient agitation in first developer.
Colors strange	Chemical contamination.
	Outdated or improperly stored film.
	Film tank not cleaned before use.
Blue spots	Iron in processing water.
Residue on transparencies after drying	Hard water used for wetting agent.

Courtesy Unicolor Photo Systems.

cessity for extra equipment (an iron) required. Plastic-insertion mounts are a bit more expensive, but their ease of use, their sturdiness, and the lack of need for extra equipment make them a very attractive choice.

If you have followed instructions, the mount should be white (plastic), or clear of type (cardboard) when you are looking at the transparency's base side. It should "read" correctly. A professional approach to your work requires that you properly label your transparency. At a minimum, you should have your name, the date of the slide, and an adhesive red dot (for slide tray insertion) on the face of the mount. You could also add information about the location, the subject, the title of the picture, and so on.

Push Processing. All films, negative and positive, may be *pushed.* We may pretend that the film is rated at an ISO other than its real one, as long as we compensate for this change in development. Underexposing (rating an ISO 1000 film at ISO 2000, for example) and overdeveloping will increase the contrast and grain of the picture. Overexposing (rating an ISO 1000 film at ISO 500) and underdeveloping will decrease the contrast of the picture. Abnormal development times

STORAGE AND MOUNTING OF NEGATIVES AND TRANSPARENCIES

3-9A Cut film into strips of appropriate length.

3-9B Insert film strips into storage pages.

3-9C For both processes, cut the filmstrip into individual frames.

3-9D For plastic insertion, first simply place a frame into the indentations in one half of the mount.

3-9E Step 2.

3-9F Next place the other half-mount over.

3-9G Press together.

3-9H For heat-mount, place a frame into the indented space in half of the mount, base side up.

3-9I Carefully fold the other half of the mount over the first.

3-9J Cover the mount with a protective sheet of paper, then iron it for about 30 seconds on the lowest "synthetic fabric" setting.

3-9K If a heat-slide mounter is used, insert the closed side of the mount first.

3-9L When the heated bars are closed, the transparency will stay in place.

3-9M Gather a roll of adhesive "dots," a stamp with your name, a date stamp, and a stamp pad.

3-9N A simple method for labeling slides.

can also alter the "balance" of color, since all three emulsions may not react equally to the change.

You may use the information in Table 3.8 to experiment with push processing.

The Balance of Light Color and Film

While all color films are composed of three emulsion layers, each sensitive to the additive primaries of red, green, and blue, not all color films are equally *balanced*. Balance refers to the coordination of a particular set of emulsions with a particular color of light. The balance of light source with film will result in a rendering of the scene in its natural colors, those our mind has become accustomed to expect.

Color Temperature. Each film is manufactured to be exposed to light of a particular *color temperature*. As we noted in chapter 2, the color temperature indicates the color of the light, measured in *Kelvin degrees*. A number of Kelvin temperatures, and their light sources, are indicated in figure 3.10. Note that the lower the Kelvin temperature, the more toward the red end of the spectrum the light source will be. Higher temperatures indicate a bluer light source.

Table 3.8 Push Processing

UNICOLOR RAPID E-6	
ISO CHANGE	FIRST DEVELOPER TIME CHANGE
4 × normal	Add 4 minutes
2 × normal	Add 2 minutes
1/2 × normal	Subtract 2 minutes

KODAK FLEXICOLOR C-41	
ISO CHANGE	DEVELOPER TIME CHANGE
4 × normal	Add 3 minutes and 15 seconds
2 × normal	Add 1 minute and 40 seconds
1/2 × normal	Subtract 1 minute

KELVIN TEMPERATURE SCALE

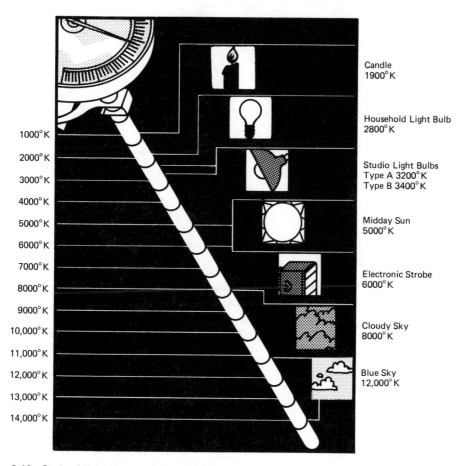

Candle
1900°K

Household Light Bulb
2800°K

Studio Light Bulbs
Type A 3200°K
Type B 3400°K

Midday Sun
5000°K

Electronic Strobe
6000°K

Cloudy Sky
8000°K

Blue Sky
12,000°K

1000°K
2000°K
3000°K
4000°K
5000°K
6000°K
7000°K
8000°K
9000°K
10,000°K
11,000°K
12,000°K
13,000°K
14,000°K

3-10 Scale of Kelvin temperatures and light sources.

Colors that we normally associate with warmth—reds, yellows, oranges—are actually *lower* in Kelvin temperature than colors we might call cool.

Daylight and Tungsten Emulsions.
Daylight and tungsten light are the most common sources of illumination, and most color films are balanced for exposure to one or the other. The ideal color of light for exposing daylight film is that which usually occurs dur-

ing a sunny midday, about 5500K. Although that color temperature is the ideal, exposures made with electronic flash at 6000K, and "warmer" sunlight at 4500–5000K, are also well within the range of the film.

Tungsten films are balanced for flood lamp illumination and are often used when rendition of correct color is most crucial. *Type A* film is balanced for 3400K bulbs, and *Type B* film is balanced for 3200K bulbs.

Negative films for amateur use are al-

most exclusively daylight balanced. Professional films are generally designated "Type L," or "Type S," rather than by Kelvin temperature balance. Type L is actually balanced for 3200K light, but the critical factor in using the film is its exposure time, which must be $\frac{1}{10}$ second or *longer*. Type S, on the other hand, is balanced for 5500K light; it is more important to remember, however, that it is meant for *short* exposures of faster than $\frac{1}{10}$ second. Color shifts for both films, if they are exposed to the "wrong" color of light, may be adjusted in printing. However, using the wrong exposure times with these films may result in an uncorrectable color alteration in the emulsion.

Reversal films carry no such "L" or "S" designations, and both amateur and professional films are marked for either daylight or a specific tungsten illumination.

Infrared Emulsions. Infrared "light" is electromagnetic radiation below the visible spectrum, made up of wavelengths longer than those for red. The infrared range extends all the way to wavelengths we would associate with the sensation of heat. Most panchromatic films (color, and black and white) are somewhat sensitive to infrared, but certain films are balanced with emulsions more sensitive to infrared than to visible wavelengths. (See colorplate 10.)

The three emulsion layers of infrared color reversal film (Kodak's Ektachrome infrared film) are sensitized to red, green, and infrared instead of the usual red, green, and blue. During processing, the dyes produced in the various layers are different than normal also: green-sensitive produces yellow, red-sensitive produces magenta, and infrared produces cyan. Since all three layers of emulsion are also sensitive to blue light, a yellow filter is usually used to block that color during exposure. Without any filtration, under daylight illumination, the transparency has an overall magenta cast. By changing the color

filters used during exposure to alter the amount of visible light that will be recorded, you can experiment with a great range of color schemes.

Color Conversion: Making Light and Film Match. When you use color film, it is obvious that the naturalness of the colors you record will be determined by the balance of light source and film. If *daylight* film is exposed to *tungsten* light, the photograph will have a distinct yellow-orange cast. Conversely, a scene photographed on tungsten film exposed under daylight illumination will appear quite blue. (See colorplates 11-12)

The use of *conversion filters* will allow you to photograph under the "wrong" illumination, converting the color of the light available to a color more appropriate for the film being used. The decision as to whether to use conversion filters is an artistic one. There *are* situations in which a shift in "normal" color is an integral part of the picture. The green-blue cast of fluorescent light, the orange glow of sunset, and the blue shadows of a snowy landscape can all be modified by conversion filters. The critical problem is not really in knowing *how*, but in knowing *when* to convert.

Color conversions are more critical when you are using reversal film, because any color casts will be difficult to correct when the pictures are projected. Color negative film may be corrected to some extent in printing, although it is always easier to print a properly balanced negative. The basic conversions from daylight to tungsten, and vice versa, are found in Table 3.9.

Light, Film, and Filters: Mireds for Coordination. Using basic terms such as *daylight, tungsten,* and *fluorescent,* we can evaluate the type of light illuminating our subject, and match it to a particular film. There are times, however, when the balance of light and film must be more critically accurate for

Table 3.9 Filter Compensation for Mired Shifts

FILM BALANCED FOR K	LIGHT SOURCE K	FILTER AND COLOR	FILTER FACTOR IN F-STOPS	MIRED SHIFT
5500	3200	80A/blue	$2\frac{1}{3}$	− 131
5500	3400	80B/blue	2	− 112
5500	3800	80C/blue	1	− 81
5500	4200	80D/blue	1	− 56
3200	2800	82C/blue	$\frac{2}{3}$	− 45
3200	3000	82A/blue	$\frac{1}{3}$	− 21
3400	3200	82/blue	$\frac{1}{3}$	− 10
3200	3200	None	None	0
3400	3400	None	None	0
3200	3400	81A/yellow	$\frac{1}{3}$	+ 18
3200	3600	81C/yellow	$\frac{1}{3}$	+ 35
3400	5500	85	$\frac{2}{3}$	+112
3200	5500	85B	$\frac{2}{3}$	+131

From The Photo-Lab Index, Courtesy Morgan & Morgan

perfect rendering of colors than our visual estimates can make possible. In such situations, light color must be corrected with filters other than the standard conversions, and light temperature must be more exactly gauged.

The *mired* system provides a precise method for matching color film balance, light source temperature, and color conversion filters. A mired number refers to a specific light color and is found by dividing 1 million by a Kelvin temperature number. "Mired" stands for *mirco-reciprocal degrees*. Mireds are used because the exact shift of color balance produced by a filter depends on the color of the light source. Under different lighting conditions, the same filter could easily under- or overcorrect, if the light/film relationship were not precisely identified. By accurately describing the light color and film relationship, you may select the perfect conversion filter.

The first step in using the system is to determine the exact color temperature of the light source. With electronic flash or studio lighting, the color temperature is often indicated on the unit. Otherwise, a color temperature meter, such as a Minolta Color Meter II or a Gossen Sixticolor, is essential. These me-

ters average the colors of light illuminating the subject and are sufficiently accurate for most work.

As an example, we might be using tungsten reversal film balanced for 3200K under diffuse window light which we have determined to be 4900K. Our next step is to convert *both* Kelvin temperatures to mireds:

Light Source Film

$$\frac{1,000,000}{4900K} = 204.00 \qquad \frac{1,000,000}{3200K} = 312.50$$

The *mired shift* is determined by subtracting the mired of the light source from the mired of the film:

Film	minus	Light	equals	Mired Shift
312.50	−	204.00	=	108.50

The mired shift may be either a positive or negative number. When it is positive, the color temperature of the light must be "warmed" by using yellow, brown, or orange filters. When the number is negative, a "cooling" of the light by use of a blue filter is indicated. In our example, the mired shift of

108.50 can be compared with the mired shifts in Table 3.9, to indicate the use of an 85 (amber) filter. Whichever filter is indicated, it is important to remember to alter the camera exposure to compensate for the amount of light absorbed by the filter, using the filter factor. Remember that if you are using a through-the-lens metering system, the filter factor will automatically be compensated for.

If you do not have access to a color light meter, the Nomograph, figure 3.11, should help you determine the correct filter for an "incorrect" match of light and film.

CC Filters and Fluorescent Light. Light color temperatures can also be altered by using *color compensating filters* ("CC" for short). CC filters are available in both additive and subtractive primary colors and are identified by a series of numbers and letters which indicate their color and density. For example, *CC 50Y* can be broken down to indicate:

CC = color compensating
50 = the actual density of the filter, multiplied by 100. In this case, .5 × 100 = 50.
Y = yellow

CC filters may be used for a number of different purposes, among them: to balance the light source for a variance in the emulsion which has been set during its manufacture; to purposely create an abnormal color shift; to balance unusual lighting situations; to compensate for light filtered through tinted glass or colored drapery. CC filters also may be used in color printing when the enlarger has no color head.

Under fluorescent light illumination, CC filters are indispensible. Fluorescent light is discontinuous, containing a select number of light wavelengths and no others. The light is so different from other types of illumination that color conversion filters alone are relatively useless.

While standard filters such as FL-D for daylight film, and FL-B for tungsten emulsions, may be used to compensate for fluorescents, the color rendering may be less than exactly accurate. Still, they are an inexpensive, simple means of conversion.

With the aid of a special three-color meter, a very accurate indication of fluorescent light color and mired shift may be obtained. These meters are prohibitively expensive for most nonprofessional photographers, however.

Reciprocity and Color. There are times when not only the color of light, but the *lack* of light will cause shifts in the color balance of photographs. Before sunrise, after sunset, and in dimly lit interiors the exposure times are often much longer than we might normally use. Usually, increases in exposure may be compensated for by a normal change of aperture. For exposures longer than about one second, however, the normal coordination of aperture with shutter speed will actually *underexpose* the film.

Film reacts much more slowly to long exposures than it does to those we normally use. This effect is known as *failure of reciprocity*. When using black-and-white film, we may simply increase exposure time even further to compensate for this tendency to underexpose. With color films, lengthy exposures will result in shifts in color balance, because all three emulsions do not react to the reciprocity effect in the same manner. Some color films come with instructions recommending a particular combination of filters to correct for long-exposure color shifts. The filters require even *longer* exposures, though, which can increase the effect even more drastically.

There *are* times when reciprocity shifts give the picture a color impact which can be achieved in no other way. The unusual lighting conditions and imbalance of emulsions make the process difficult to control. Don't let the unpredictability of the reciprocity effect

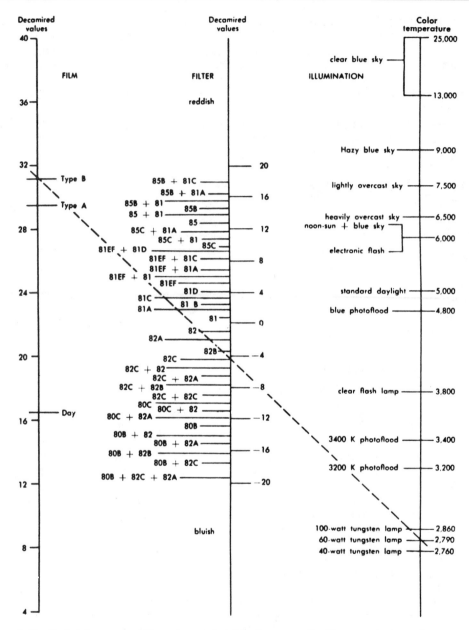

3-11 To find the required filter, place a straight edge across the Nomograph connecting the type of color film you are using with the type of light in which the shot will be made. Find the correct filter at the point where the straight edge crosses the center column. Example: Type B color film and a 60-watt bulb require an 82C filter. From *The Color Photo Book* by Andreas Feininger, © 1969 by Andreas Feininger, published by Prentice-Hall, Inc.

keep you from experimenting with it! *Bracket* your exposures, making a number of them at various times and aperture settings to be sure that at least one will be usable.

Instant Color Processes

The time between exposure of color film and the final viewing of a positive print or transparency can be great—not only because most of the developing processes take more than a few minutes, but also because there is no necessity (other than anxiety) to process such materials immediately.

"Instant" photography, most closely associated with Polaroid Corporation and its products, alters the color photographic process in two ways. First, the minutes/hours/days of darkroom work necessary to produce a satisfactory color print are eliminated, allowing for immediate use of the photograph. This is especially important for photographic illustrators, graphic designers, newspaper and magazine photographers, and others working under deadline pressures. Second, the narrowing of the gap between exposure and image production changes the photographer's response to subject, not only in terms of exposure and composition, but also in terms of its "meaning."

Composition, angle of view, subject expression, lighting, may all be altered as a result of the insights gained from viewing the first exposure immediately after it is made. In fact, many commercial and art photographers use instant materials both as a means for producing an original print and for an accurate preview of the results they will get with regular color film.

Although Kodak makes instant color films, including Kodamatic Trimprints, which look and feel like a noninstant print, Polaroid has the most firmly established and versatile line of products. Special cameras and holders are made for the over 30 black-and-white and color films which range in size from 35mm to 8-by-10 inches. Emulsions are available in color print, color transparency, black-and-white print and transparency, X-ray, and many others.

The two most commonly used Polaroid color emulsions are Polacolor 2 ER and 600 Land film. The introduction of both films marked important advances in color technology. The Polachrome Autoprocess System, while not as widely used as yet, has become an important tool for 35mm photographers.

Polacolor. A Polacolor negative contains three layers of silver halide emulsion, each sensitive to one of the three additive primary colors, and three dye developer layers. The dye developers are molecules that include both image-forming dyes and developer groups. Directly underneath each light-sensitive emulsion is a layer of chemistry which includes the corresponding subtractive primary color dye developer. Underneath the blue-sensitive emulsion is a yellow-dye-developer layer, and so on.

After exposure, the negative is brought in contact with a sheet of specially treated *receiver* paper. The two are then pulled through a set of rollers which spread a thin film of *reagent* chemistry between them. The reagent penetrates the layers of the negative and activates both the dye-developers and an auxiliary developer. Dye developers then migrate from the negative to the receiver paper, with the developing silver in each layer of emulsion immobilizing a proportional amount of dye from passing through. Once the migration of dyes to the receiver paper is completed, a positive color picture has been formed there and is ready for viewing. The negative and positive print are peeled apart, and the negative, emptied pod of chemistry, along with paper enclosure, are discarded. The print does not require coating but will take a few minutes to dry to a smooth, hard gloss. During this drying time it is essential to protect the print from dust, abrasive surfaces,

SCHEMATIC CROSS-SECTIONS OF POLACOLOR 2 (*left*) AND POLAROID SX-70 (*right*) PROCESSES

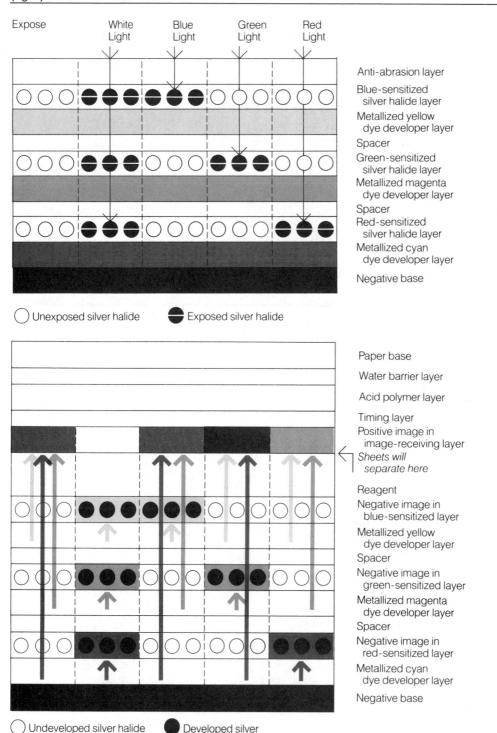

Expose | White Light | Blue Light | Green Light | Red Light

Anti-abrasion layer
Blue-sensitized silver halide layer
Metallized yellow dye developer layer
Spacer
Green-sensitized silver halide layer
Metallized magenta dye developer layer
Spacer
Red-sensitized silver halide layer
Metallized cyan dye developer layer
Negative base

○ Unexposed silver halide　◒ Exposed silver halide

Paper base
Water barrier layer
Acid polymer layer
Timing layer
Positive image in image-receiving layer
Sheets will separate here
Reagent
Negative image in blue-sensitized layer
Metallized yellow dye developer layer
Spacer
Negative image in green-sensitized layer
Metallized magenta dye developer layer
Spacer
Negative image in red-sensitized layer
Metallized cyan dye developer layer
Negative base

○ Undeveloped silver halide　● Developed silver

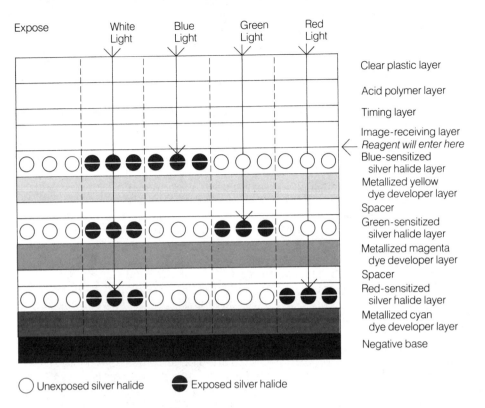

Expose

White Light | Blue Light | Green Light | Red Light

Clear plastic layer

Acid polymer layer

Timing layer

Image-receiving layer
Reagent will enter here

Blue-sensitized silver halide layer

Metallized yellow dye developer layer

Spacer

Green-sensitized silver halide layer

Metallized magenta dye developer layer

Spacer

Red-sensitized silver halide layer

Metallized cyan dye developer layer

Negative base

◯ Unexposed silver halide ◑ Exposed silver halide

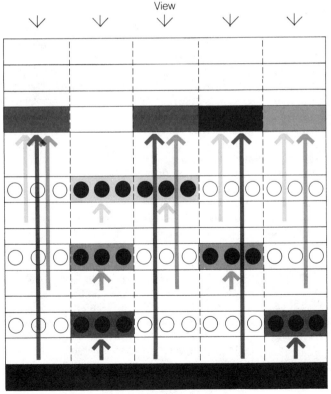

View

Clear plastic layer

Acid polymer layer

Timing layer

Positive image in image-receiving layer visible from above

White pigment component of reagent

Negative image in blue-sensitized layer

Metallized yellow dye developer layer

Spacer

Negative image in green-sensitized layer

Metallized magenta dye developer layer

Spacer

Negative image in red-sensitized layer

Metallized cyan dye developer layer

Negative base

◯ Undeveloped silver halide ● Developed silver

Courtesy Polaroid Corporation

fingerprints, debris, and anything else that might mar the delicate material. Do not stack wet prints. Colors shift slightly during drying also, so do not make any adjustments in filtration on the basis of how a moist print looks.

Polacolor film is available in a wide variety of types and sizes and has an ISO of 75 in daylight. The film requires 1 minute for processing, but this time varies with different ambient temperatures. Many photographers use an ultraviolet filter with Polacolor to remove some blue from daylight scenes.

When using Polacolor 2 with exposures longer than $1/10$ second, reciprocity failure causes more and more of a shift in print color to cyan. This is objectionable if you are exposing in daylight, but it may be compensated for. Try an 81B plus .05R CC filter combination at 1-second exposures to compensate. If you are using the film under tungsten lights, however, the color shift from long exposure compensates quite nicely for the warmer color of illumination. You can bring this daylight film well into the range of tungsten balance merely by making long exposures *without* a filter.

Beyond balancing the film and light with filtration, there are two crucial steps that you can take to ensure quality Polacolor pictures. First, the rollers through which the film, paper, and chemistry pod must pass should be *very* clean. Any dust, scratches, or chemical residue on the rollers will show up as repeated marks running the length of the photograph. Second, you must pull the film assembly through the rollers in a straight and steady, even manner. Stopping during this crucial step, pulling too quickly or too slowly, or pulling one side more than the other, will result in mottling of the print.

Polaroid SX-70. SX-70 film, and its descendants Time-Zero Supercolor and Polaroid 600, are integral color positive films. The negative and positive images are both contained in one "package" and are not separated.

Polaroid integral films come in hard plastic packets holding ten sheets each. Built into this packet is a set of Polapulse batteries which powers the camera. After insertion into the appropriate Polaroid camera, the cardboard cover which protects the film from light during loading is automatically ejected by a motor drive. The topmost sheet of film is now ready for exposure. During exposure, light passes through the upper layers in the sheet, including the image-receiving layer, which will hold the positive picture. The film sheet is ejected after exposure through a set of rollers, which break a pod of reagent located in the bottom portion of the film border. The reagent is spread between the upper and lower layers of the film.

Development is automatic and does not require timing as in the Polacolor film process. During development, the light-sensitive negative is protected by opaque dyes in the reagent, so the process may take place even in bright sunlight. As you look on in wonder, a number of things happen simultaneously. Silver halides are reduced to metallic silver in exposed areas of each of the three additive primary light-sensitive layers, and complementary subtractive primary dye developers are immobilized. In unexposed areas dye developers migrate through the layers of the negative, and finally through the opaque reagent layer, which becomes a white background for the color image. Dye developers are blocked from moving up to the positive image area by developing silver, in the same manner as they are in the Polacolor film process. Blue-sensitive layer silver blocks yellow dyes, but not magenta and cyan dyes, from becoming visible, and so forth.

After a few minutes all dyes not blocked by developed silver have migrated through the white opaque layer and become visible through the clear plastic top layer. The process automatically ends, and stabilizing reactions result in a finished print.

Integral films are daylight balanced but can be exposed under a variety of light

sources for special effects. CC filters may be used over the camera lens to alter color balance.

When used normally, the film achieves Edwin Land's goal of one-step photography, with nothing more than the touch of a button needed to produce a color photograph almost instantaneously.

Polachrome. In 1983 Polaroid introduced its first 35mm instant film. This film may be used with any regular 35mm camera without any adaptations. This was another first for Polaroid, which usually makes its film solely to fit its own or its licensees' cameras.

Polachrome is an additive-color, line-screen, positive-transparency film. Alternating lines of red, green, and blue, each 8 *microns* in width (that means 394 sets of three colored lines per centimeter), form a screen on one side of the film. During exposure, light must first pass through these colored lines, which act as color separation filters for a single layer of high-resolution panchromatic black-and-white emulsion. The film is developed in an AutoProcessor by simply winding the film onto a spool inside the device, and then winding it back. A silver diffusion process develops both the negative and the positive black-and-white image. After the nega-

3-14A Gather an exposed role of Polaroid Polachrome film, the processing cube that came with it, and a Polaroid AutoProcessor 35mm.

3-14B Before you start: Check that the film cartridge and processing pack contain the same film type and number of exposures, and that the lot numbers (stamped on labels) match. The films may be processed at temperatures within a fairly wide range, as specified in the film instructions. Be sure that all components are within this range. Best results are obtained at 70 f (21 c). After the roll of film has been exposed rewind the film in the camera as usual, except that the leader should not be rewound into the cassette. It should extend from the cassette as shown. If the film has been rewound into the cartridge, use the film leader extractor supplied with the AutoProcessor to pull it out.

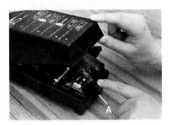

3-14C Place the processor on a clean, level surface. Pull out the top of the latch (A), then open the processor cover.

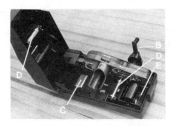

3-14D Unfold the crank handle (B). Check that the pressure plate (C) and both metal rollers (D) are clean. Blow out any dust or lint inside the processor. If necessary, grasp and turn the large spool so the clear lid is at the top, and open the lid (E).

3-14E Unhook the end of the processing pack leader and pull out 1-2 inches.

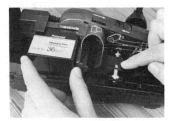

3-14F Insert the processing pack into its compartment. The processing pack should snap easily into position; if it does not, remove and reinsert it.

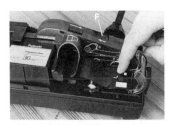

3-14G Feed the processing pack leader *over* the metal roller and attach to the white pear-shaped pin on the spool. The leader should lie flat. If you have pulled out too much leader, causing it to buckle, you should rewind the excess as follows: Push the switch (F) in the direction shown by the arrow. Hold it in this position, and turn the crank in a clockwise direction until the leader lies flat.

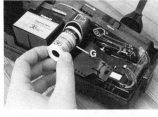

3-14H To load the film cartridge, align it as shown and insert the leader behind the bar (G). Then seat the cartridge in its holder.

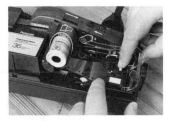

3-14I Attach the leader to the white hook, then to the pear-shaped pin, on the spool.

3-14J Close the spool lid. The leader should lie flat as shown. If you have pulled out too much leader, turn the wheel (H) in the direction shown by the arrow until the film lies flat. Close the processor cover, and be sure it latches.

3-14K PROCESSING THE FILM. Grasp the control lever firmly, and push it down at a steady medium speed. WAIT 5 SECONDS.

3-14L Turn the processing crank in a clockwise direction, as indicated by the arrows on the crank. Turn at a medium speed, no faster than about two revolutions per second, without slowing down or stopping. When you no longer hear the clicking of the gear, you have reached the end of the film. *Stop turning immediately.* WAIT 60 SECONDS. This is the correct processing time for most AutoProcess films.

3-14M Grasp the control lever firmly, and pull up at a steady, medium speed.

3-14N Turn the processing crank in a clockwise direction as indicated by the arrows on the crank. Turn the crank steadily and briskly, at about 3 revolutions per second. Keep turning until you no longer hear the clicking of the gear, then continue turning for another 3-4 revolutions.

3-14O Open the processor cover. After removing the processing pack, put it back in its original box and discard it immediately. Unhook the film leader and remove the film cassette.

3-14P The film is ready to be cut and mounted.

Courtesy Polaroid Corporation

tive and other processing layers are stripped away inside the AutoProcessor, you will be left with a black-and-white positive, filtered by the color screen which remains in place. The resulting color transparency is thus based on additive color light blending, rather than the subtractive theory. The development process is completed in minutes.

Polachrome film has fairly good resolution, at 90 lines per mm. It is a daylight balanced film, with an ISO of 40. Being a black-and-white image—it appears in color only because of the filters—the image should be very stable. The processing unit is lightweight and does not require power, a darkroom, precise temperature controls, or chemical baths. Its portability makes processing possible anywhere.

There are a few unique characteristics of the film which should be kept in mind by photographers accustomed to more standard color films. First, while the images project

well, care should be taken to use a flat-field projection lens, and avoid lenticular screens which may cause a moiré pattern. An 8-by-10-inch enlargement may show the filter screen lines rather clearly on close examination. These same lines can cause problems when transparencies are to be reproduced photomechanically, or when the film is used to make pictures of video monitors. In both instances, clashing of lines in the film with other line-image processes may cause a moiré pattern to be formed. Also, since light must first pass through the color screen before it strikes the Polachrome emulsion, dedicated flash units and cameras that meter off the film will not give accurate exposures. See the film instruction sheet for recommended adjustments.

These slight drawbacks in Polachrome film are more than offset by its accurate color rendering, and especially its instantaneous processing.

Color Film Stability

The complex chemical structure of color film makes proper storage of both processed and unprocessed film essential. Processed and unprocessed films are seriously affected by heat, high humidity, and air pollution.

Unprocessed Film. Before processing, film damage may affect the ISO, color balance, and relative contrast. Most films are packaged by the manufacturer in foil wrap, plastic cannisters, or some other system for protection against humidity. Always leave the film in this protective packaging until you are ready to load the camera. When possible, reuse the packaging to store the film between exposure and processing.

The packaging will also protect the film from harmful gases. Motor exhausts, paints and solvents, mothballs, and industrial-strength cleaners all give off gases which may damage film emulsions.

Film designated as "amateur" is manufactured so that the changes in emulsion that might occur during room temperature storage and shipment from factory to store will result in normally balanced emulsions. These emulsions *can* change for the worse if left on store or home shelves too long. "Professional" films are meant to be kept refrigerated from the time of manufacture until shortly before exposure. In any case, the ideal storage place for maintenance of film color balance is your refrigerator or freezer. If you will be traveling, put the film in a portable insulated cooler and avoid placing it in direct sun. Temperatures inside a parked, closed, automobile can reach 160°F. (71°C.) and higher on hot, sunny days. Never leave film in such conditions. The trunk of the car will be cooler than the inside when parked, so leave your film-laden cooler there.

If film has been refrigerated or frozen, it should be given time to assume ambient temperature *before* you open the package. If it is opened while still cool, moisture may con-

3-15 For long term storage of unexposed color film, a refrigerator provides an ideal temperature and humidity controlled environment.

dense on the emulsion with ruinous effect. Table 3.10 indicates suggested warm-up times for single packages of film. If packages are stacked on top of each other, much greater times will be required.

Unprocessed film must also be protected from all radioactive materials such as are found in many hospitals, industrial sites, and airports.

Airline passenger check-in stations invariably X-ray carry-on luggage. While the low dosages of such devices will not usually affect the film noticeably, a faulty machine or repeated exposures can seriously damage

Colorplate 6 Predawn. Changes in light color occur throughout the day. Stay alert for the new picture opportunities that these changes provide.

Colorplate 8 Midday

Colorplate 7 Dawn

Colorplate 9 Keep your camera ready for everyday occurrences of refraction, and other phenomena.

Colorplates 11—12 Using daylight-balanced film under tungsten lamps, or tungsten-balanced film under daylight, produces shifts that you should be aware of. Correct for them with an 80A filter (left) or 85B filter (right).

Colorplate 10 Infra-red film with a red filter transforms a normal backyard into a quite different scene.

Colorplates 13, 14, 15 When photographing under fluorescent lamps, tungsten-balanced film will often record a cyan cast. This can be corrected somewhat with a FL-B filter. Using daylight film in the same lighting results in a greenish cast, which may be modified by an FL-D filter.

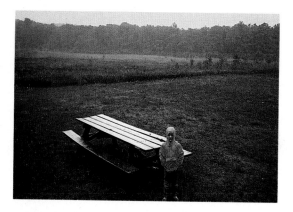

Colorplate 16 Don't be afraid to take your (protected) camera out in the rain. The stark contrast of yellow in the drizzly blue-green environment is made possible by the inclement weather.

Colorplate 17 A real "pea-souper" can transform even the most ordinary of residential neighborhoods. Watch for objects, headlights, or people that suddenly loom out of the fog.

Colorplate 18 Instead of standing awe-struck by a sunset, or simply photographing it, examine your environment. Try to make a record of the physical and emotional effect of the light, in a new *personal* way.

Colorplate 19 Marvelous alterations of subject matter are possible when daylight film is exposed to *nightlight:* street lamps, neon, and moonlight for example. Look for illuminations which give new meaning to an ordinary scene.

NEGATIVE CHROMOGENIC PRINT, from exposure through development.

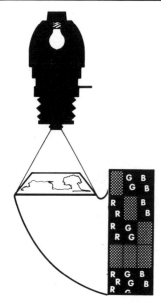

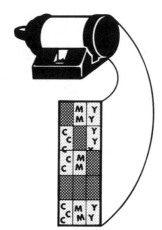

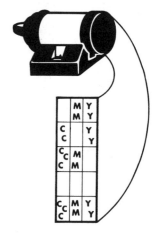

4-1A Exposure to the negative image causes a reaction in each layer, depending on the amount and color of light that strikes it. For example, the more yellow light to which the paper is exposed, the more silver halide crystals will react in the green and red layers of emulsion (remember that green and red light make yellow light).

4-1B Development with an alkali mixture of chemical agents produces both metallic silver *and* subtractive complement colored dyes in each layer of the emulsion. The green and red layers of emulsion affected by our yellow light exposure will now contain both silver and dyes: magenta in the green-sensitive layer and cyan in the red-sensitive layer. The dyes result from the interaction of chemicals known as *color couplers* with the by-products of development.

4-1C The final step in print development is removal of the silver deposits and undeveloped silver halides, leaving the dye image. This process is commonly referred to as *bleach-fix*, or *blix*. Metallic silver produced during development is changed to silver bromide by the bleach, and then it and the undeveloped silver halides are removed from the emulsion by the fixing agent.

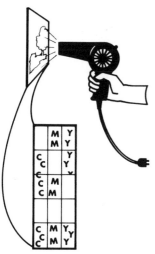

4-1D After a brief water wash, the print is often given a short soaking in a formaldehyde-based stabilizer. The stabilizer helps retard dye fading and contains a wetting agent which will minimize water spotting. The print, like all other resin-coated (RC) materials, is then air-dried. RC prints are never heat ferrotyped, since they would melt.

Color Transparency to Reversal Print. Chromogenic print paper used for printing from positive color transparencies is very similar in structure to that used for printing color negatives. The paper consists of three layers of gelatin silver halide emulsion, each sensitive to one of the three additive primary colors. Each layer will also produce its subtractive complement colored dye during development. The main difference between the two papers is the development process to which each is subjected. Ektachrome 22 made by Kodak, and Unichrome by Unicolor, are commonly used papers of this type. (See figure 4.2)

Color Transparency to Dye Destruction Print. Unlike chromogenic print paper, dye destruction paper already contains the dyes that will make up the final picture. Each red-, green-, and blue-sensitive layer of gelatin silver halide emulsion contains its subtractive complement colored dye. There are no color coupler chemicals in dye destruction paper, since dyes are not produced during processing. Cibachrome A-II by Ilford is the best-known paper of this type. (See figure 4.3)

Dye destruction prints and chromogenic prints from positive transparencies have many similarities and differences. The

REVERSAL CHROMOGENIC PRINT, from exposure through development.

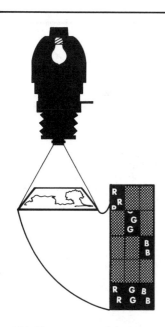

4-2A After exposure to light passed through a transparency, the three layers of emulsion have been affected in the same manner as a negative-to-positive printing paper would be. Red-, green-, and blue-sensitive layers exposed to their respective colors of light have undergone a chemical change.

4-2B During the first development step, however, while metallic silver is produced in these layers, no dyes are formed. If the print were fixed at this stage, we would see that the first developer had produced a black-and-white negative image of the color transparency. If the color dyes had been produced during this first development, the image would be a color negative as well.

4-2C After a water wash, color developer is used. This combination of chemicals affects areas of the emulsion not altered during the first development. During this stage, silver halides still left in the paper are broken down to metallic silver. At the same time, dye couplers produce subtractive color dyes in exact proportion to the amount of silver development in this step. In effect, two positive pictures are produced at the same time: one in metallic silver, and one in color dyes.

4-2D At this point the print looks black. It contains both positive and negative black-and-white images and a color positive. The final processing step of bleach-fix removes all metallic silver and silver halides from the paper, leaving only the color positive.

4-2E After a brief wash and a soak in optional stabilizer, the print is ready for air drying. The production of dyes in areas *not* affected by exposure gives this print its characteristic black borders.

most obvious similarity is that positive pictures result because a color dye image appears in areas not affected by exposure during printing. This causes both types of prints to have black rather than white borders. The major difference lies in the means by which color dyes are produced in the paper. Cibachrome's Azo dyes, which are incorporated during the paper's production, are extremely stable and brilliant. They are also very costly. Chromogenically produced dyes tend to fade more rapidly and unevenly. While they are also generally less vivid, they are certainly less expensive.

Ektaflex PCT Process for Negative and Reversal Printing. The Ektaflex PCT (Photo Color Transfer) print system by Kodak has more in common with "instant" films than

with ordinary chromogenic and dye destruction printing papers. In fact, Ektaflex is a direct result of the research that led Kodak to its PR-10 instant film for cameras. (See figure 4.4)

Paper Supports. Color printing papers available today are almost universally *resin coated*. The base support for the color image is no longer simply a piece of paper. A "sandwich" of a very light sheet of paper coated with resin on both sides is the standard base. The resin coating acts as a waterproof seal for all but the edges of the paper, greatly reducing the wash time necessary after processing. The coating also provides a sturdy support, without the amount of paper formerly required. Most RC papers are coated with a variety of chemical emulsions,

DYE DESTRUCTION PRINT, from exposure through development.

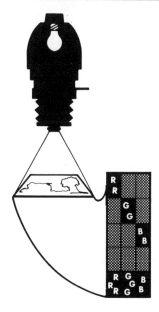

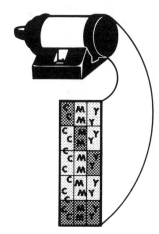

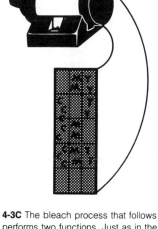

4-3A During exposure, silver halides in the three layers of emulsion react in proportion to the amount of red, green, and blue light passing through the positive transparency.

4-3B This latent image is made visible through production of metallic silver by the developer. If we could see this picture, it would appear as a black-and-white negative.

4-3C The bleach process that follows performs two functions. Just as in the processing of a chromogenic print, the bleach removes metallic silver produced by development. In dye destruction printing the bleach also removes layers of dye in exact proportion to the amount of silver it affects. For example, after exposure and development, an area in which blue- and green-sensitive layers were affected would contain silver coupled to yellow and magenta dyes. Bleaching the silver back to a silver halide would eliminate the yellow and magenta dyes coupled to it in the print.

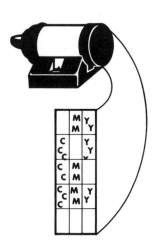

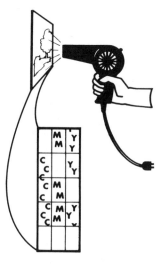

4-3D A fixing bath removes both the undeveloped silver halides and those produced by bleaching.

4-3E After a brief water wash, the print is air-dried.

EKTAFLEX PCT PROCESS, from exposure through development.

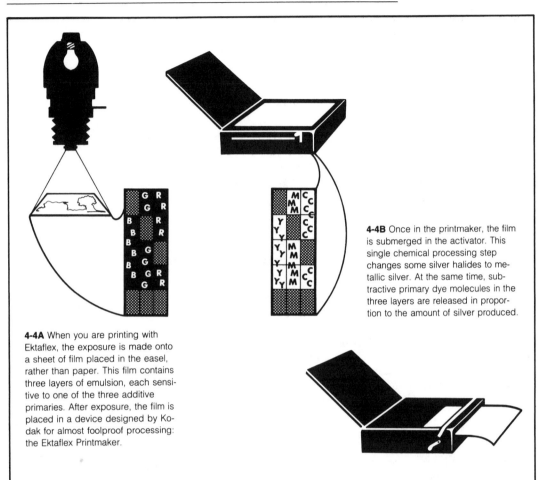

4-4B Once in the printmaker, the film is submerged in the activator. This single chemical processing step changes some silver halides to metallic silver. At the same time, subtractive primary dye molecules in the three layers are released in proportion to the amount of silver produced.

4-4A When you are printing with Ektaflex, the exposure is made onto a sheet of film placed in the easel, rather than paper. This film contains three layers of emulsion, each sensitive to one of the three additive primaries. After exposure, the film is placed in a device designed by Kodak for almost foolproof processing: the Ektaflex Printmaker.

4-4C The next stage of processing laminates the emulsion of the film sheet to the emulsion of the PCT paper. The emulsion of the paper is *not* light sensitive. It is *mordanted*, meaning it is treated to induce dyes from the film to begin migrating to the paper as soon as the two emulsions are placed in contact. The dyes are chemically fixed in position on the receiving paper, and after a brief period of time, the transfer of image from film to paper is complete. Since both the film and RC receiving paper have opaque bases, the transfer can occur under normal room lights. The only steps that must be carried out under darkroom light conditions are

the exposure of the film and its 20-second soaking in the activator.

The same RC receiving paper is used for printing both negatives and positive transparencies, from either PCT negative or PCT reversal films. Unlike chromogenic and dye destruction papers, Ektaflex paper contains only one layer of gelatin emulsion. There are no light-sensitive chemicals in the emulsion. Since dyes migrate to the paper but are not produced there, only a single receiver layer is needed.

In the negative film, layers of emulsion that are exposed to light will produce metallic silver *and* release dyes during the activator step.

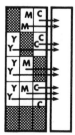

This results in a positive image from a negative original. In the reversal film, layers of emulsion that are *not* exposed to light will produce metallic silver and release dyes during the activator step. This results in a positive image from a positive original.

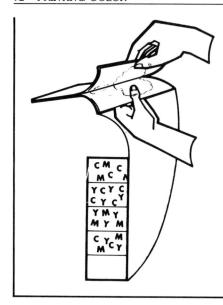

4-4D There are no processing steps other than submerging the film in the activator and laminating it to the receiver paper. The paper is not washed after being peeled apart from the film, and it air-dries in just a few minutes.

depending upon what process is to be used and whether they are meant to be exposed to negatives or positive transparencies. RC papers for use in Kodak's Ektaflex process contain no such light-sensitive emulsion; the gelatin coating of the paper is simply mordanted. Ilford's Cibachrome papers come in two forms, RC and an opaque polyester.

The Color Darkroom

In addition to having certain specialized equipment and chemicals that are necessary for each printing process, there are steps of preparation that you must take before any system can be used. Even a darkroom that is perfectly suited to black-and-white printing will require a few modifications. Ideally, the darkroom will be in a permanent location, such as a basement or other little-used space. A permanent setup will allow you to print any time you like, with minimum start-up time. However, any room that can be made light-tight and is well ventilated may be used both as a darkroom and for other processing activ-

4-5 Proper ventilation is essential for safety when printing color.

4-6 Ideally, you will have a fairly permanent darkroom.

4-7 But a temporary set-up can be just as functional.

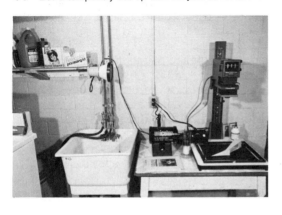

4-8 If your darkroom is to be set-up each time you print, you will have to find an efficient storage system. An unused baby changing table will hold all your supplies, and doesn't take up much space.

4-9 Lightleaks

ities. When the darkroom must be "taken down" after each printing session, a convenient storage system must be developed.

Lightleaks. Perhaps most obviously, the darkroom must be *dark*. To check for lightleaks, turn the lights off in the room and allow a few minutes for your eyes to adjust. At this point, any lightleaks should be clearly visible. Still in the dark, mark the leaks (which are usually in wall, floor, or ceiling corners or edges) with a crayon. When the lights are turned on, these leaks may be easily filled with brown or black caulk.

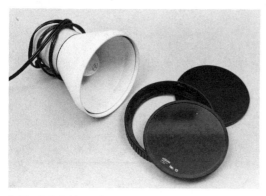

4-10 Safelight

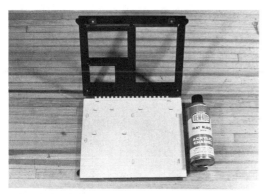

4-11 Easel, before.

4-12 Easel, after.

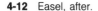

Safelight. The OC safelight filter used when you are printing black and white must be replaced by a #13 filter. This safelight filter, even though it is much darker than an OC, is useful only for printing from negatives. When you are printing from positive slides, no safelight should be used. As we will see, the amount of time actually spent in the dark is limited only to the steps of exposing the light-sensitive material and then loading it into a processing device. This brief period of time, coupled with the extreme dimness of the #13 filter, makes a safelight an accessory rather than a necessity.

Easel. The easel you have used to hold your black-and-white print paper was probably painted yellow by the manufacturer. This was done so that light passing through the paper during exposure would reflect back to the paper only in a color to which the paper is not sensitive. Color printing paper, whether for use with transparencies or negatives, *is* sensitive to this yellow color and will be fogged by it. Only Ektaflex film and Cibachrome A-II glossy, which have opaque backings, will not be affected by this reflection. For this reason, any easel meant to be used with color print processes must be spray-painted matte black.

Enlargers and Filters. An enlarger normally used for black-and-white printing must be altered so that the color of light striking the paper may be adjusted. Changes in color of light from the enlarger alter the amount of dyes produced in the print. A simple way to change the color balance of the enlarger light is through the use of CC or CP filters.

CC, or *color correction*, filters are optically pure gelatin acetate filters which are placed in a holding drawer below the lens. They may be had in each of the additive and subtractive primary colors, in a variety of densities. Since CC filters alter the light *after*

4-13 CC Filter

4-15 CP Filter

4-16 CP Filter

it has been focused, image distortion, lack of sharpness, and loss of contrast can result from dirt, scratches, or excessive stacking. Always use the smallest number of filters possible to effect the filter change you want. (For example, use one CC40 instead of two CC20s.)

CP, or *color print*, filters are many times less expensive than CC filters. Because they are placed in the enlarger head, and alter the color of light *before* it reaches the negative or transparency, CP filters are not as op-

4-14 CC Filter

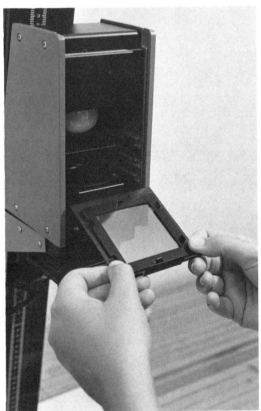

tically pure as CC filters. CP filters are available only in the subtractive primary colors, plus 50Red (equal to 50Magenta and 50Yellow) and ultraviolet. They are cataloged in a system of notation similar to that of CC filters. An ultraviolet filter and sheet of heat-absorbing glass are always inserted in the enlarger head to protect film and shield paper from ultraviolet exposure.

CC and CP filters may be used with either condenser or diffusion enlargers, but not with "cold light" enlarger heads.

An enlarger suitable for black-and-white printing may also be modified for color printing by replacement of its light source. Enlarger manufacturers, as well as some independent companies, make *color heads* for most popular black-and-white enlargers. Most of these color enlargers are simply a standard chassis with the light source changed from a simple incandescent bulb to a sophisticated system of filters and color-corrected reflector light bulb: a color head. Dials on the head allow you to move thin glass filters across the path of light. These filters, known as *dichroics*, contain metallized dyes. Dichroic filters are categorized just as CC and CP are—a number for density and a letter for color: 50M + 90Y refers to a .5 density magenta and a .9 density yellow filter combination.

Dichroic filtering systems have a number of advantages over other methods. Filter settings can be much more finely tuned than with CC or CP sets, which must be altered in steps of at least .05 density. Filter packs are more quickly and easily set, making darkroom work less tedious. Ultraviolet and infrared filters are usually built in, and there is generally a greater range of filtration density available.

Neutral Density. All dichroic enlargers and CC/CP filter sets contain cyan, magenta, and yellow, but all three are almost never used together. Each subtractive filter blocks one of the three components of white light—red, green, or blue. If all three subtractive filters were used at one time, the effect would be not only to alter the relationship between red, green, and blue in the light mix, but to eliminate some of *all three.* This "neutral density" effect would merely make your print exposure longer, or require a larger aperture. The same proportional color change could be accomplished by using only two of the subtractive primary filters. When printing from negatives, we usually change the proportions of light by altering only magenta and yellow filtration. When printing from transparencies, we usually use only cyan and yellow filters.

4-17 Dichroic color heads.

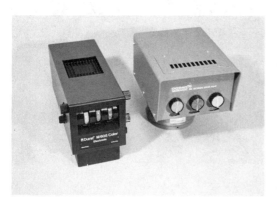

4-18 Kodak Color Print Viewing Filters.

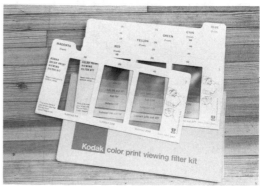

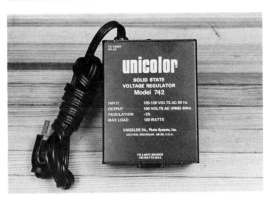

4-19 Voltage Regulator

4-20 Temperature Controller

Color Print Viewing Filters. Color print viewing filters (CPVFs) will aid you in determining changes you must make in the enlarger filter pack in order to make a proper color print. They allow you to preview the change in print color that should result from a specific filtration change. A set of CPVFs contains six colors, each primary, in gradations of three density levels.

Voltage regulator. Any changes in the voltage supplying power to the enlarger will change the color of the light source. Whether you are using CC/CP filters, adding a color head to a black-and-white enlarger, or using an integrated color enlarger, a voltage regulator should be connected between the light source and electric outlet. Without one, changes in color balance would be practically unpredictable because of the possible effects of power surges on light color.

Temperature Control System. For most color print processes, control of chemistry and rinse temperatures is a necessity. Variations of as little as $1/2°F$. can alter color balance and density noticeably. Rinse temperature is easily and quickly controlled by water faucets. The simplest method for controlling chemistry is the *water bath* method. Bottled chemistry is immersed in either hot or cold water until it comes to the required

temperature. The bottles are then placed in a tray containing water of the same temperature, and with regular changes of this "bath," may be kept at proper processing levels. While this method is simple, it also requires constant monitoring and is less than exact. There will be more than enough for you to be concerned with in the color darkroom without having to constantly check the temperature of your chemistry.

A number of companies market excellent temperature control storage tanks. These tanks use either immersion heaters or recirculating pumps to maintain a continuous temperature level. The extra cost of these systems is more than made up for by their convenience and the consistent results they make possible.

Processing Drum and Motor Base. Consistent print processing agitation is also necessary for predictable color printing results. The introduction of the processing drum and its companion, the motor base, has made consistency easily attainable, with a few added benefits as well.

After exposure the print is loaded into the drum, which is then sealed with an end cap. Unlike the case with tray processing, the lights may then be turned on and all chemical steps accomplished in room light. The drum is filled with very small amounts of chemistry

4-21 Drums and Motor Base

4-22 Notebook

(6 ounces for 16-by-20-inch size, 4 ounces for 11-by-14, and 2 ounces for 8-by-10), which is dumped after each print. Since fresh chemistry is used for each print, there is no need to worry about the rate of chemical exhaustion and its effect on print color and density. The drums may also be used to process more than one print at a time. The 16-by-20-inch drum may be used to process one 16-by-20 or two 11-by-14 or four 8-by-10 prints during one "run."

Although the drum may be rolled by hand to agitate the print and chemistry, processing is most consistent when a motor base does the job. There are motor bases that turn continuously in one direction, or that alternate back and forth. Whichever base is chosen, two factors must be considered in setting it up: first, the drum must be level in order for the chemistry to flow evenly across

the paper; second, the motor is an electrical appliance and should *never* be placed in water.

Notebook. Buy a notebook which you will keep by your enlarger and use *only* for printing information. Set up a series of columns on each page:

Negative/Transparency #
Paper and Emulsion #
Exposure
Enlarger Height

This information will help you keep track of all the changes you make in exposure, whether it is for your first test-strip or what you hope will be your final print. By comparing your results with your changes, you will quickly become able to make filter and other changes with confidence. The records will be valuable in the future as well, should you decide to reprint a favorite picture. They will give you a ballpark figure to start from.

Safety. FIRST!! All chemicals associated with color photographic processes should be considered dangerous—and treated as such. You should wear rubber gloves in any situation in which your hands may come in contact with chemicals. Adequate ventilation must be available, because the chemistry can be absorbed by inhalation as well as by direct contact. Chemistry

© UNICOLOR DIVISION, Photo Systems,

MADE IN U.S.A.

4-23 Observe all precautions. Your respect for safety is as important as your understanding of technique.

should always be stored out of reach of children, and bottles should be safety-capped or taped shut as an extra obstacle to little fingers. Use plastic rather than glass bottles, and check them periodically for leakage.

Read labels carefully in order to determine emergency procedures necessary in case of accident. Stop reading this book *right now*, pick up a phone, dial information, and get the number of your local Poison Control Center. Both Kodak and Ilford have experts available twenty-four hours each day to answer questions on chemical hazards and emergency treatment procedures. Their telephone numbers are: Kodak, (716) 722-5151; Ilford, (914) 478-3131.

Since many of the chemical processes involve the use of electronic devices, it is essential that all wiring be grounded. *Never* mix electricity and liquids, and never touch an electronic device with one hand while your other hand is touching a liquid. Do not use coffee heaters, hot plates, or other devices not designed for darkroom use to heat photographic chemistry. Check all wires regularly for fraying or damage.

Print Processes: Step by Step

In this section we will move step by step through four different processes for making color prints. The procedures conform closely to those recommended by their manufacturers. If you feel the urge to alter these steps after you have tried them, do so! Working in a darkroom is a very personal experience, and your work methods should reflect that fact. You should remember, however, that the times and temperatures outlined here have been determined to be optimal for most normal print requirements.

Whichever processes you use, two things must not be compromised: cleanliness and consistency. Without a clean darkroom, and regular rinsing and drying of equipment, contamination of chemistry is inevitable. Contamination will result in spoiled prints, wasted time, and frustration—none of which is conducive to fun in the darkroom. It is also important to be absolutely consistent in your processing procedures, even if they vary from the norm. Agitation, time, and temperature all must be consistently repeated in order for predictable results to be obtained. No matter which printing process you use, there are a number of steps which must be taken common to all.

Standard Negative/Transparency for Print Balance. On your first attempt at color printing, you will no doubt feel the urge to insert what you feel is your "best" color transparency or negative in the enlarger. Restrain yourself. You *may* eventually get a good print of that landscape, sunset-lit portrait, or macro study, if you print it first. However, you will learn a lot more about the process of color printing, and waste a lot less time, chemistry, and paper, by first printing a simpler picture. Your reference picture will ideally contain a human being whose flesh tone you are familiar with, and possibly a gray card and variety of other colors. The simpler the picture the better, because for your first printing session you will want to concentrate on adjusting exposure and color balance in an *objective* rather than *interpretive* manner.

Shoot your reference picture under normal lighting conditions for the film you are us-

PROCEDURES COMMON TO VARIOUS PRINT PROCESSES

4-24A Look over your film page, and pick an appropriate picture.

4-24B Place film in enlarger carrier, emulsion side down. For Ektaflex prints, emulsion side should face up.

4-24C Clean film carefully with soft brush . . .

4-24D or, use compressed air to remove surface dust.

4-24E Flip lever on dichroic head, removing filtration, or remove filters if you are using CC or CP sets. White light will make it easier for you to . . .

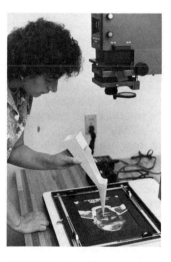

4-24F focus the image, whether it is a negative, or . . .

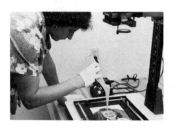

4-24G a positive transparency.

4-24H Be sure to replace filters.

4-24I Check the filter pack recommended for your film/paper combination, or check your notes to determine your last successful setting.

4-24J Set filters in enlarger.

4-24K Set your aperture at f5.6

4-24L Set your timer at 10 seconds. *Turn out the white lights in the dark-room.*

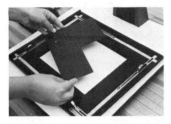

4-24M Remove a sheet of paper, and place it in your easel. Place a sheet of cardboard the same size as the paper over the sheet. One quarter of the cardboard should be cut away as shown.

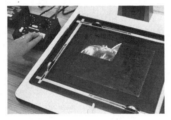

4-24N Expose paper at f5.6, 10 seconds.

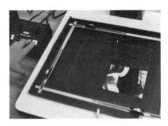

4-24O Move the cardboard, and stop down the aperture one setting each time, until each quadrant of the paper has received a 10 second exposure at a different aperture.

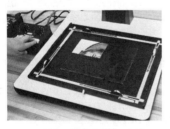

4-24P, Q Do the same for a transparency. Your exposures should be, f5.6, f8, f11, f16, all at 10 seconds.

4-24R Set up processing drum, and make sure it is level. Plug drum into timer.

4-24S, T After following the appropriate process, you may examine the

test exposures under room lights.

ing, and bracket a variety of exposures so you will have one with proper density. With daylight film, avoid the warm light of sunrise and set.

Follow the steps outlined for the printmaking process you are using. Change print color balance and density until you have made a normal print for your familiar subject, using procedures outlined under *color print evaluation.*

The filter and exposure combination used to make your normal reference print will give approximately the correct exposure for other pictures on the same roll of film made under similar lighting conditions. These combinations may be used as a starting point when you are printing from another roll of the same type of film.

Color Print Evaluation. Whether you are printing from negatives or transparencies, or using any of the processes outlined in this chapter, your first step is determining the correct exposure for a properly balanced print.

We will use a series of test exposures on a single sheet of paper to zero in on the combination of aperture and time that will give us the correct density. Using a cardboard "mask," we can expose the four different quadrants of a single sheet to different amounts of light. Since color print paper is prone to reciprocity changes as exposures get longer or shorter, we will use a single time for each quadrant but will change aperture settings. Generally, color print paper should be exposed for approximately 10 seconds, so we will try to find an aperture setting that will allow us to make an exposure in the 8- to 15-second range.

The correct exposure will be determined by examining the density in a "highlight" area of the print. An area that should appear with textured detail, such as a gravel walkway or tan corduroy pants, yet be lighter than middle values, is a "highlight." *Don't* examine white automobiles, glare from windows, or shiny metal poles. Tonal values for

such print areas do not contain the kind of textured detail that a highlight should. Don't evaluate shadow areas either, or any area in which the tone would be darker than middle gray. These areas can look correct at a number of different exposures and can easily be manipulated when the final print is made by burning or dodging (discussed in a later section).

Once the exposure combination to achieve correct print density has been determined, shift your gaze from the highlights to the middle tones. Determining whether the color balance of the print is correct is the final step. The highlights and shadows may have actual or perceived color casts because of color contrasts or because of the light illumination at the time of film exposure. It will be easier to see "incorrect" color balance in the middle tones.

It may be obvious to you that there is an excess of red, green, blue, cyan, magenta, yellow, or some combination in the print. Probably in your first attempts at color printing, evaluating the colors in excess will not be so easy. The reference sets of "ring-around" pictures for transparencies and negatives (colorplates 4 and 5) will help you in determining how great a change in filtration must be made to produce a normal print. By comparing the changes in print color in the samples, you can estimate the filter pack changes you will need to make for your own print.

Another method for determining the filter pack for a properly balanced print is to use color print viewing filters. After you have made a print of proper density, view it through the filter that is the *complement* of the color you think is in excess. For example, if the print looks too green, you would view it through the various magenta viewing filters. If you have made the correct choice, the print color balance should look normal through one of the filter densities. Information on the viewing filter will indicate the change you should make in the filter pack to improve the print.

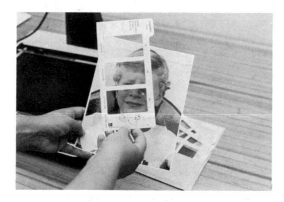

4.25 Use Color Print Viewing Filters after you have determined the correct aperture/time combination for proper print density, to preview changes in print color you may wish to make. Determine new filter pack, and change enlarger settings so you may make a final print.

Filter Pack Changes. In printing from negatives, if a color is in excess in the print, you will want to change the filter pack so that *more* of that color of light affects the next print you make. For example, if the print were too blue, you would remove some yellow filter density from the filter pack. In the next exposure, more blue light will affect the print, which will result in more yellow dye. The more yellow dye in the print, the less blue it will look.

When printing from positive transparencies, however, since it is a reversal process, you would do just the opposite. If the print looks too blue, you would want *less* blue light to affect the next print. To accomplish this, you would *add* yellow filtration to the filter pack.

The rules of thumb are: for *negative* printing, alter the filter pack so that there will be *more* of the color light that is in excess in the print; for printing from *positive* transparencies, alter the filter pack so that there will be *less* of the color light that is in excess in the print.

If you are using a dichroic color head, changes in filter pack should have little impact on print density. If you are using CP or CC filters, however, be sure to follow the manufacturer's instructions for changes of exposure to compensate for filter changes.

Tables 4.1 and 4.2, along with Colorplates 4 and 5, will help you in determining appropriate filter changes for color balance.

Table 4.1 Positive-to-Positive Print Correction Guide **Before evaluating the color balance of your print, be sure that it has thoroughly dried.**

NECESSARY CORRECTIONS

Print Is:	Either	Or
Too light	Reduce exposure time	Stop down lens aperture
Too dark	Increase exposure time	Open up lens aperture
Too blue	Subtract magenta and cyan	Add yellow
Too red	Subtract yellow and magenta	Add cyan
Too green	Subtract yellow and cyan	Add magenta
Too yellow	Subtract yellow	Add magenta and cyan
Too cyan	Subtract cyan	Add yellow and magenta
Too magenta	Subtract magenta	Add yellow and cyan

Photocopy this page and tack it up in your darkroom.

Table 4.2 Negative-to-Positive Print Correction Guide Before evaluating the color balance of your print, be sure that it has thoroughly dried.

NECESSARY CORRECTIONS

Print Is:	Either	Or
Too light	Increase exposure time	Open up lens aperture
Too dark	Decrease exposure time	Stop down lens aperture
Too blue	Subtract yellow	Add cyan and magenta
Too red	Subtract cyan	Add magenta and yellow
Too green	Subtract magenta	Add cyan and yellow
Too yellow	Add yellow	Subtract cyan and magenta
Too cyan	Add cyan	Subtract yellow and magenta
Too magenta	Add magenta	Subtract cyan and yellow

Photocopy this page and tack it up in your darkroom.

NEGATIVE TO POSITIVE PRINT. For this process, we will use Kodak Ektacolor paper and Kodak Ektaprint 2 chemistry.

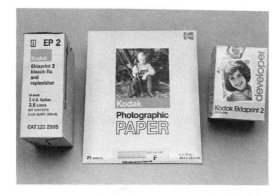

4-26 *Kodak Ektaprint 2 Process.*

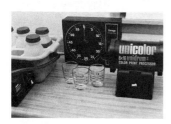

4-27A Mix chemistry with distilled water, then gather equipment for printing. Bring chemistry to temperature, and check ventilation.

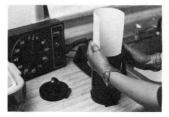

4-27B *Turn off white lights*. Remove paper from package, expose, and insert in drum. The room lights may now be turned on.

4-27C Check temperature of water and chemicals.

4-27D Fill drum with 91°F. (32.8C.) water.

4-27E Agitate for 30″, then drain.

4-27F Measure out developer.

4-27G Set timer for 3′30″ and pour Developer in drum.

4-27H Start timer and drum will agitate.

4-27I 10 seconds before time has ended, dump developer, do not save.

4-27J Measure out stop bath.

4-27K Set timer for 30″ and pour stop bath in drum.

4-27L Start timer and drum will agitate.

4-27M 10 seconds before time has ended, dump stop bath, do not save.

4-27N Measure out bleach-fix.

4-27O Set timer for 1′00″ and pour bleach-fix in drum.

4-27P Start timer and drum will agitate.

4-27Q 10 seconds before time has ended, dump bleach-fix, do not save.

4-27R Remove print from the drum.

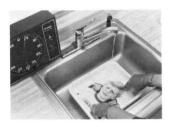

4-27S Wash the print in running water for 3'00".

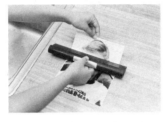

4-27T Squeegee print, or blot with paper toweling.

4-27U A hair dryer will speed drying considerably.

Table 4.3 Summary of Steps for Drum Processing Using Kodak Ektaprint 2 Chemicals at 91°F. (32.8°C.)

PROCESSING STEP	TIME IN MINUTES	ELAPSED TIME
Pre-wet with water	30"	30"
EP2 developer	3'30"	4'00"
Stop bath	30"	4'30"
Rinse	30"	5'00"
Bleach-fix	1'00"	6'00"
Wash	3'00"	9'00"
Air-dry	As required	

A 10-second drain time is counted as part of each step.

Courtesy Eastman Kodak Co.

Table 4.4 Amount of Solution per Drum Size

	8" × 10"	11" × 14"	16" × 20"
Pre-wet and rinses	500ml	1000ml	1500ml
Chemistry	70ml	130ml	260ml

Table 4.5 Storage Time of Working Strength Solutions at Room Temperature (60°-80°F.)

SOLUTION	FULL, TIGHTLY CLOSED BOTTLE	PARTIALLY FULL, TIGHTLY CLOSED
Developer	6 weeks	2 weeks
Stop bath	Indefinitely	Indefinitely
Bleach-fix	8 weeks	2 weeks

Table 4.6 Troubleshooting for Prints from Negatives

PROBLEM	PROBABLE CAUSE
High contrast, cyan stain and/or high cyan contrast (pink highlights and cyan shadows)	Contamination of developer or pre-wet by bleach-fix. Developer temperature too high.
Magenta, blue streaks	Insufficient stopping action (stop bath is exhausted or contaminated, or no stop bath used).
Red streaks	Differential wetting of print by developer when no pre-wet used.
Pink streaks	Water on print prior to processing, caused by inadequate drying of tube and/or cap.
Light and dark streaks	Pre-wet not used. Insufficient developer agitation. Processor tube not level.
Blue blacks	Diluted developer. Insufficient development. Insufficient drain after pre-wet.
Low contrast	Diluted developer. Insufficient volume of developer. Insufficient agitation. Developer temperature too low.

Courtesy Eastman Kodak Co.

Table 4.7 Summary of Steps for Drum Processing Using Unicolor RP-1000 Chemicals at 90°F. (32°C.), with 105°F. Pre-wet and Washes

PROCESSING STEP	TIME IN MINUTES	ELAPSED TIME
Pre-wet with water	1'00"	1'00"
First developer	2'00"	3'00"
Wash #1	2'00"	5'00"
Color developer	4'00"	9'00"
Wash #2	30"	9'30"
Blix	2'30"	12'
Wash #3	1'30"	13'30"
Air-dry	As required	

A 10-second drain time is required, but should not be counted as part of a step.

Courtesy Unicolor Photo Systems

COLOR TRANSPARENCY TO REVERSAL PRINT. For this process, we will use Unichrome paper with Unicolor RP-1000 chemistry.

4-28 *Unicolor RP-1000 Process.* Mix chemistry with distilled water, then gather equipment for printing. Bring chemistry to temperature, and check ventilation.

4-29B Check temperatures of chemistry and water.

4-29A Set filtration as per paper instructions, or your recent experience.

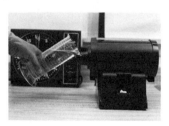

4-29D Set timer for 1'00", fill drum with 90F. (32C.) water, and agitate. Drain.

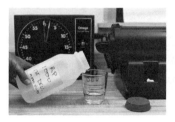

4-29E Measure out first developer

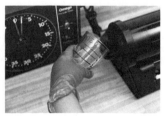

4-29C *Turn off white lights.* Remove paper from package, expose, and insert in drum. The room lights may now be turned on.

4-29F Set timer for 2'00" and pour first developer in drum.

4-29G Start timer and drum will agitate.

4-29H At the end of process time, dump first developer. Do not save.

4-29I Fill drum with tempered water, set timer for 2'00", start timer and agitate 15 seconds, dump, fill, and repeat until time has ended.

4-29J Dump final wash.

4-29K Measure out color developer

4-29L Set timer for 4'00" and pour color developer in drum.

4-29M Start timer, and drum will agitate.

4-29N At the end of process time, dump color developer. Do not save.

4-29O Fill drum with tempered water, set timer for 30", start timer and agitate.

4-29P At the end of wash time, dump water.

4-29Q Measure out blix.

4-29R Set timer for 2'30" and pour blix in drum.

4-29S Start timer and drum will agitate.

4-29T At the end of process time, dump blix. Do not save.

4-29U Fill drum with tempered water, set timer for 1'30", start timer and agitate 15 seconds, dump, fill, and repeat until time has ended. Dump wash.

4-29V Remove print from drum.

4-29W Squeegee print, or blot with paper toweling.

4-29X A hair dryer will speed drying considerably.

Table 4.8 Amount of Solution per Drum Size

	8″ × 10″	11″ × 14″	16″ × 20″
Pre-wet and rinses	500ml	1000ml	1500ml
Chemistry	70ml	130ml	260ml

Table 4.9 Storage Time of Working Strength Solutions at Room Temperature (60–80°F)

SOLUTION	FULL, TIGHTLY CLOSED BOTTLES
Unopened chemistry	Up to 2 years
Opened concentrates	Up to 12 months
Working strength	Up to 2 weeks

Table 4.10 Troubleshooting for Reversal Print

PROBLEM	PROBABLE CAUSE
Print dark with magenta highlights	Too little first development from low temperature, too short time, weak or old developer.
Print dark with grayish highlights	Underblixing from too low temperature, too short time, weak or old solution.
Print light, lacking color saturation or having abnormal colors	Too little color development from low temperature, too short time, weak or old solutions. Contaminated first developer.
Print streaked	Too little solution used. Drum rolling surface not level.
Blue spots on prints	Iron contamination of solutions.
Minus density spots or mottled effect	Moisture condensation on cold paper.
No maximum density (borders not black) or print too "washed out"	Too much first development. Solution too warm or too much time given.

Courtesy Unicolor Photo Systems

Table 4.11 Summary of Steps for Drum Processing Using Cibachrome P-30 Chemistry at 75°F. (24°C.)

PROCESSING STEP	TIME IN MINUTES	ELAPSED TIME
Developer	3′00″	3′00″
Rinse with water	30″	3′30″
Bleach	3′00″	6′30″
Fixer	3′00″	9′30″
Wash	3′00″	12′30″
Air-dry	As required	

A 15-second drain time is required but should not be counted as part of a step.

Courtesy Ilford, Inc.

Table 4.12 Amount of Solution per Drum Size

	8″ × 10″	11″ × 14″	16″ × 20″
Pre-wet and rinses	100ml	200ml	300ml
Chemistry	75ml	140ml	280ml

COLOR TRANSPARENCY TO DYE DESTRUCTION PRINT. For this process, we will use Cibachrome A-II paper and Cibachrome Process P-30 chemicals.

4-30 *Cibachrome P-30 Process.* Mix chemistry with distilled water, then gather equipment for printing. Bring chemistry to temperature, and check ventilation.

4-31A Set filtration as per paper instructions or previous experience.

4-31B Check temperatures of chemistry and water.

4-31C *Turn off white light.* Do not use a safelight. Remove paper from its package, remembering that the emulsion side faces a label affixed to the sealed bag. Expose paper and insert in drum. The room lights may now be turned on.

4-31D Measure out developer.

4-31E Set timer for 3'00" and pour developer in drum.

4-31F Start timer and drum will agitate.

4-31G At the end of process time, dump developer in a plastic pail.

4-31H Fill drum with tempered water, set timer for 30″, start timer and agitate.

4-31I At the end of process time, dump down drain.

4-31J Measure out bleach.

4-31K Set timer for 3′00″, and pour bleach into drum.

4-31L Start timer and drum will agitate.

4-31M At the end of process time, dump bleach into same plastic pail.

4-31N Measure out fixer.

4-31O Set timer for 3′00″, and pour fixer in drum.

4-31P Start timer and drum will agitate.

4-31Q At the end of process time, dump fixer into plastic pail also. Mixing the developer, bleach, and fixer together is necessary to neutralize the chemistry. The mixture may now be dumped down the drain.

4-31R Remove print from drum.

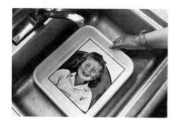

4-31S Wash print for 3'00", then squeegee and air dry as per Unicolor RP-1000 process.

Table 4.13 Storage Time of Working Strength Solutions at Room Temperature (60–80°F.)

SOLUTION	FULL, TIGHTLY CLOSED BOTTLES	PARTIALLY FILLED, TIGHTLY CLOSED
Concentrate liquids	1 year	
Concentrate bleach	5 years	
Developer working solution	8 weeks	4 weeks
Bleach working solution	8 weeks	4 weeks
Fixer working solution	6 months	6 months

Table 4.14 Troubleshooting for Dye Destruction Print

PROBLEM	PROBABLE CAUSE
Light "flare" on print	Stray light has fogged paper.
Dark print with deep orange/red cast	Exposure through the back of print (Lustre RC only).
Black print, no image	Exposure through the back of print (Glossy only).
Orange cast over entire print, black areas bluish	Developer contaminated by fixer.
Gray areas with uneven print tones	Not enough processing chemistry used.
Dark print, flat contrast	Developing time too short.
Light print with no blacks	Developing time too long.
Dull print with milky appearance	Bleaching time too short.
Dark, fogged, dull print	Print fixed before bleaching.
Flat, yellowish appearance	Fixing step omitted.
Black print with slight image	Bleaching step omitted.

Courtesy Ilford, Inc.

Table 4.15 Summary of Steps for the Ektaflex PCT Process at 70°F

PROCESSING STEP	TIME IN MINUTES	ELAPSED TIME
Activator	20"	20"
Lamination	6'00"	6'20"
Air-dry	As required	

Courtesy Eastman Kodak Co.

EKTAFLEX PCT PROCESS FOR NEGATIVE AND REVERSAL PRINTING. For this process, we will use Kodak Ektaflex PCT Negative Film.

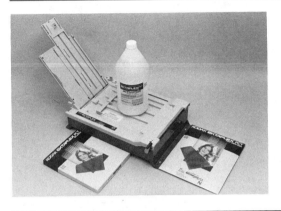

4-32 *Ektaflex PCT Process.* Assemble processor, and gather activator and other equipment for printing, check ventilation.

4-33A Either screw processor into countertop, or hold it down with "duct" tape.

4-33B Fill tray with activator. Determine room temperature, and activator time.

4-33C Place paper, which is not light sensitive, white side down, grey side up, on processor bed.

4-33D Move paper to left to touch rakes.

4-33E Flip negative or transparency in enlarger so that emulsion side is facing *up.*

4-33F *Turn off white lights.* Remove film from package, place in easel, and expose. Film emulsion is up, when notch is in lower left of one edge.

4-33G Remove film from easel, and load onto ramp.

4-33H Set timer for 6'30" and start.

4-33I At 6'20", push film into lower tray.

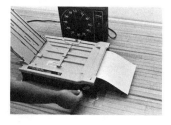

4-33J . . .

4-33K At 6'05", begin turning handle at a rate of two revolutions per second.

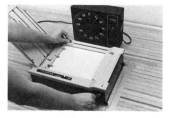

4-33L At 6', push handle 5 to the right, moving film and paper at once into rollers. When paper and film begin to pass through rollers, stop pushing 5.

4-33M Continue turning the crank.

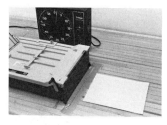

4-33N Stop turning when print and film are completely laminated, and ejected from the processor.

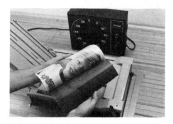

4-33O *Turn on room lights*. Wait six minutes then peel film from print.

4-33P Drain activator for reuse after each printing session has ended.

Table 4.16 Troubleshooting for PCT Prints

PROBLEM	PROBABLE CAUSE
Uneven borders, excess white border at end that exited printmaker first	Paper advanced ahead of film into laminating rollers.
Picture crooked on paper	Paper did not enter straight into lamination rollers.
Light-colored or white areas at edge of print that exited last	Film not fully immersed in activator at beginning of soak.
White or light irregularly shaped patches in print	Film and paper did not laminate, or came apart too early.
White or light corner on edge of print	Edge or corner came apart before full lamination time.
Round dark spots with soft edges in image area	Warm fingerprints caused by handling during lamination.
Black edges greater than ⅛ inch wide into edges of print	Film emulsion stuck to paper; lamination time too long.
Blue streaks with sharp edges	Paper was wet before lamination.

Courtesy Eastman Kodak Co.

Techniques Beyond the Basic Print

The Contact Sheet. The contact sheet is an important tool. It provides a simple means of cataloging each roll of film in an organized manner. This makes it easier to keep track of subjects, and to retrieve the proper negative or transparency when needed. The contact sheet also eliminates the need to handle negatives and transparencies while searching for a picture to print. Negatives and transparencies are easily damaged, and the less handled the better. The contact sheet is especially important when you are printing from negatives since it is relatively difficult to imagine the orange-brown colored picture as a true-color one.

By reviewing all the photographs taken on one roll at the same time, you will get a better sense of the direction your eye and mind are taking you.

Negatives and unmounted transparencies should always be stored in clear

4-34 With white lights out, place the film storage page, or mounted transparencies, on the unexposed sheet of photo paper.

4-35 Cover film and paper with glass, and expose, then process.

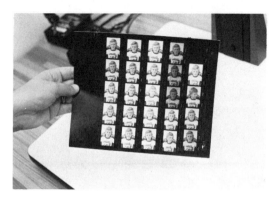

4-36 A finished contact sheet.

plastic sheets, partially because it is so easy to make a contact sheet through such storage vehicles. If transparencies are already mounted, they may be left that way. Although the images will not be as sharp as if they were in direct contact with the paper, it is not worth removing and remounting them.

Once you have made a successful enlargement of your standard picture, the same exposure time and filter pack used for the 8-by-10-inch print will usually yield a properly exposed contact sheet. The negative or transparency enlarged *must* be of the same general density and film type as the pictures to be contact-printed.

Set the aperture, timer, and filter pack to those used for making your 8-by-10 en-

largement. Remove the negative carrier from the enlarger, and mark with tape the area on the baseboard illuminated by the enlarger. This area should be more than large enough to cover a sheet of 8-by-10 paper.

Turn off the enlarger and room lights, and place a sheet of unexposed photo paper, emulsion side up, within the marked area on the baseboard. Place your sheet of negatives/transparencies on the paper, emulsion side down, with a sheet of glass on top. Expose. Process. Voila!

Burning and Dodging. As you may know from printing your own black-and-white photographs, *burning* means adding light exposure to a portion of the print, *beyond* the base exposure, and *dodging* means deleting light exposure from a portion of the print, *during* the base exposure.

When you are printing from a negative in black and white or color, burning makes an area of the print darker and dodging makes an area of the print lighter. When you are printing from a transparency onto either reversal paper, PCT reversal film, or dye destruction paper, just the opposite is true; burning makes an area of the print lighter, and dodging makes an area of the print darker.

When printing color, we may alter not only the density of a print area, but its color

4-37 Dodging

4-38 Burning

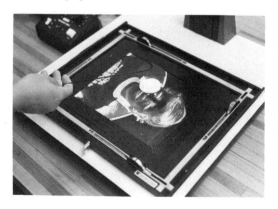

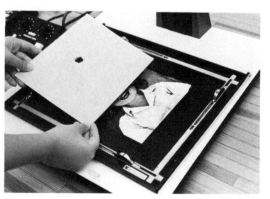

4-39 Check notebook entry.

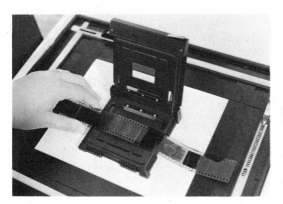

balance as well, by burning or dodging. Using CC filters below the lens, we may burn in more green light, for example, in an area of a print from a negative, making that area darker and more magenta in the final image. Or, we may burn in more green light in an area of a print from a transparency, making that area lighter and greener in the final image.

The Color Analyzer. A color analyzer is a light meter for the darkroom. Just as you use a light meter to evaluate a tonal area and determine the correct exposure for film in your camera, the color analyzer will help you evaluate the light that falls on any area of your print and determine the correct exposure for it.

4-42 Focus

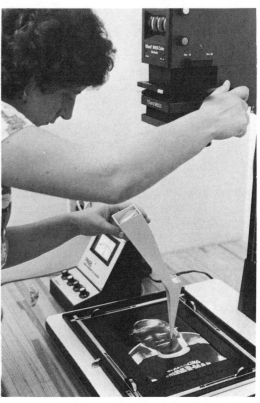

4-43 Set enlarger height, aperture, and filters to previous setting.

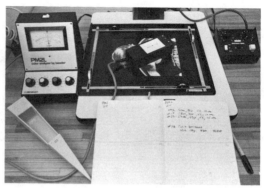

4-44 Place probe in reference area.

The analyzer is useless until you have made a successful print from a standard reference negative or transparency. Once you have made that print, enter the aperture, filter pack, enlarger height, and exposure time in your notebook. When you want to print another picture, first place the reference film image in your enlarger. Set aperture, enlarger height, and filter pack just as they were for the correct print. Now place the probe of your color analyzer on the easel and turn on the enlarger lamp. Be sure to turn room lights and safelights out also. Move the probe so that it is "reading" light from an area of the image *similar in color and density* to an

area in the new picture you will be printing. If the same person appears in both pictures, for example, then "read" the flesh tone in your reference picture.

Now, by either turning dials or adjusting levers on your analyzer, you may read separately the amount of red light, green light, blue light, and overall intensity in that one small image area. Most analyzers require you to turn dials at each setting until needles are "zeroed out." You now have a set of numerical indicators showing on the analyzer that directly relate to the area color and density you just read.

Next, remove the reference picture,

4-45-48 Adjust reading of densitometer until measurements for cyan, magenta, yellow, and exposure, have

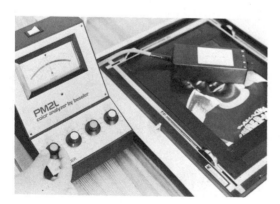

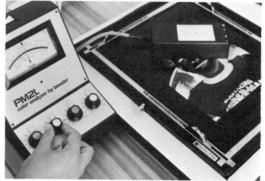

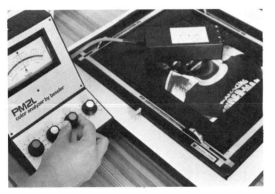

4-47

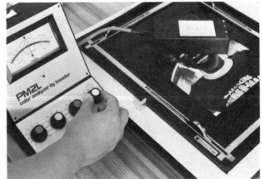

4-48

and insert and focus the new picture in the enlarger. Placing the probe on the easel in an image area that corresponds with the area you read in the reference picture, you are now ready to compare the two. There will probably be differences recorded on your analyzer as you move the dials through red, green, blue, and exposure. If you are printing from a negative, adjust the enlarger filter pack to "zero-out" the needles for green and blue, by changing its magenta and yellow components. The needle for red should be adjusted by changing the *aperture* setting rather than cyan filtration. If you are printing from a transparency, adjust the filter pack to

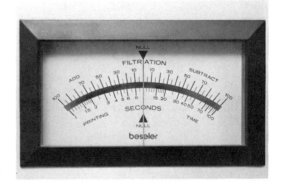

4-49 "Zeroed out"

4-50 Make a note of dial settings for future reference without standard film.

4-51 Insert new film image.

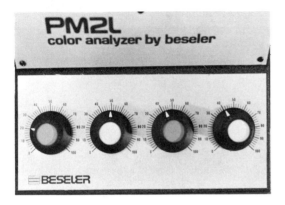

4-52 Place probe in a similar image area, both in color and density.

4-55 Adjust aperture setting to alter balance for cyan.

4-53 Adjust magenta filtration on enlarger (for negatives).

4-54 Adjust yellow filtration on enlarger (for negatives).

zero-out the needles for red and blue by changing its cyan and yellow components. The needle for green should be adjusted by changing the aperture setting. After measuring for exposure and adjusting your enlarger timer, you have adjusted the filter pack and exposure settings so that the exact same color and density should result in the new picture as in the reference picture.

Of course, the analyzer is worthless if you do not compare proper print areas. It *will* give you a setting to print a red apple purple, if you read grapes in the reference picture and apples in the new one. As they say, "Garbage in, garbage out." The analyzer *can* save

4-56 Set timer, and you are ready to print!

you a lot of time, paper, and chemistry if you understand its function and use it carefully.

Adjustment for Paper Emulsion Changes. All print paper emulsions, like film emulsions, are manufactured to strict tolerances for color balance, light sensitivity, and base characteristics. Every box of paper from any one batch should respond to a given negative or transparency in exactly the same manner. However, unless you purchase quantities of paper all having the same emulsion number, you will discover slight changes in color balance and light sensitivity between any two boxes of the same brand.

Some manufacturers print on each package recommended starting filter packs for various types of film. These recommendations are based on tests they have run with samples from the batch, and they should be followed each time you use a new package. Kodak gives Exposure Factor and Paper Filter Adjustment numbers (PFA) on each package, with which a new starting filter pack for the paper may be determined. Your first step is to determine the *basic filter value* by subtracting the PFA for the paper you have just run out of from the filter pack you used to make a good print. For example, if 50M + 95Y was the filter pack used with a paper whose PFA was + 10M − 5Y, then:

$$50M +95Y$$
minus
$$+10M -5Y$$
$$\overline{40M +100Y}$$

Thus 40M + 100Y is the basic filter value. Remember that subtracting a minus number is equivalent to adding it.

Now find the new filter pack for your enlarger with the new paper by adding the PFA from the new package to the basic filter value. If the new PFA was − 10M − 5Y, then:

$$40M +100Y$$
plus
$$-10M -5Y$$
$$\overline{30M +95Y}$$

Thus 30M + 95Y is the new enlarger filter pack for the new paper. Remember that adding a minus number is equivalent to subtracting it.

Printing Color in Black and White. Although your color negatives will normally be used to make color prints, there will probably come a time when you will want a black-and-white print instead. Perhaps one of your pictures is to be reproduced in black and white in a publication, or maybe you feel that a particular image would communicate your intent better in shades of gray than in color.

If you try to print your color negative on normal orthochromatic black-and-white paper, much of the contrast will be lost in translation. Since black-and-white papers are sensitive mainly to blue light, colors in your negative will not be rendered in appropriate shades of gray. Blues in the color scene will print too light in black and white, and reds will print too dark.

The simple solution to the problem is to use a panchromatic black-and-white paper, which will be sensitive to red and green as well as blue. Kodak's Panalure is such a paper. Panalure is made in both fiber-base and RC cool-black glossy surface, and in a fiber-base warm-tone lustre surface.

Panalure is developed in standard black-and-white print developers but must be exposed only under a #10 or #13 safelight, or no safelight at all. Since the paper is panchromatic, it would be fogged if a standard black-and-white safelight were used. Since the illumination of the darkroom is so low, the print cannot be developed by inspection as other black-and-white prints may. For this reason, it makes sense to use the drum and motor base to process Panalure so, after loading, you may work with room lights on.

Filters may be used during exposure of Panalure paper to alter the relationship of gray values. The filters have the same effect as they would if they were used on a camera loaded with black-and-white film. To make a

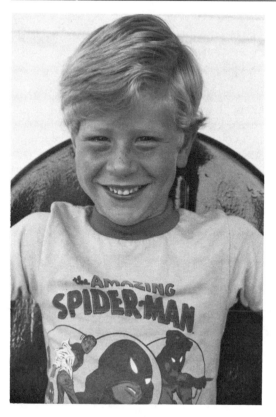

4-57 Print on orthochromatic paper from color negative.

4-58 Print on Kodak Panalure paper from color negative.

gray tone lighter, use a filter of the same color as the thing photographed. For example, the gray printed for green leaves will be lighter if a green filter is used during print exposure. To make a gray tone darker, use a filter of the color complement of the thing photographed.

Making Color Transparencies from Color Negatives. The best positive color transparency of a scene is made with color reversal film in the camera, but a close second may be made in the darkroom from a color negative. There *are* certain advantages to doing so, among them: the transparencies can be made the same size as the original negative, or larger or smaller; the color balance of the transparency may be easily al-

tered; multiple exposures from the same or different negatives may be made; and black-and-white and color negatives may be combined into one transparency. Once you start thinking about the possibilities, they seem endless.

Kodak makes materials for producing such transparencies. Kodak Vericolor Print Film 4111, which comes in sheets and rolls, and Kodak Vericolor Slide Film 5072, which comes in 35mm-by-100-foot rolls, should be exposed in the darkroom just as color print paper would be. However, *no* safelight should be used, as the films are sensitive to all visible light. After exposure, the transparencies are processed in C-41 type film development chemistry.

Transparencies may also be made with

Kodak's Duratrans Display Film 4022. This film has an emulsion similar to that of Kodak's Ektacolor papers and is processed in Ektaprint 2 chemistry. Duratrans is made primarily for producing enlarged transparencies that will be backlit for display. For this reason, the film has a white pigment in its base which acts as a diffusion material. Duratrans would not be the appropriate film for making slides that are to be projected.

Print Finishing Techniques

It often seems, after a day of solid darkroom work, that all of our efforts *must* have resulted in a final, successful print. Very often, you *will* emerge from the darkroom with perfectly exposed and color-balanced prints, but they will not be *finished*. The techniques described in this section will help you complete the job you began in the darkroom.

Retouching Prints. No matter how clean you keep your darkroom, negatives, transparencies, and equipment, it is quite likely that many of your prints will contain spots resulting from dust or other small particles. When spotting black-and-white prints, it is a simple matter to darken the white spot to the appropriate shade of gray. When spotting color prints, we must achieve not only the correct level of darkness but the correct color as well. Very often, the spot will not be white but rather a shade of some specific color. In that case, we must blend our retouching colors with the color of the spot to match the color around it. Obviously, a good working knowledge of additive and subtractive color theory is important even *after* printing.

Wet-Brush/Dry-Dye Technique: Prints from Negatives. First, apply small amounts of liquid dye to a sheet of acetate about 5 by 8 inches, in the order shown in Figure 4.60. Colors on opposite ends of each line will neutralize each other, but dyes from other manufacturers may require different color sets. Color dyes from Retouch Methods Company, the makers of Spotone for black-and-white prints, are used in this demonstration. Wait for the dyes to dry on the acetate, then gather a #0 spotting brush, a small glass of water, and a few sheets of paper toweling together. Turn on a good desk lamp, sit in a comfortable chair, and you are ready for work.

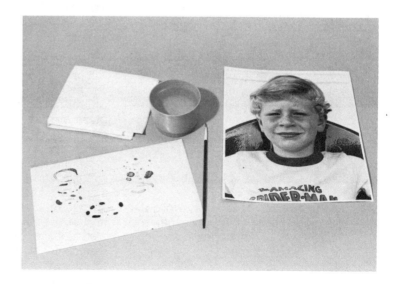

4-59 Gather a spotting spotting colors, water co print to be spotted, and toweling.

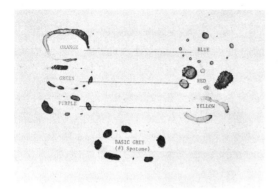

4-60 Set up colors as shown, and allow to dry.

4-61 Step 2

4-62 Step 3

4-63 Step 4

Step 1: Wet the brush by dipping it in water.

Step 2: "Draw" a line with the brush on a paper towel until excess water is removed.

Step 3: Daub brush into a *very light* concentration of appropriately colored dye.

Step 4: Carefully apply dye to the area to be spotted.

Step 5: Apply more dye, following Steps 1–4, until the spot color matches the print color around it.

Using the wet-brush/dry-dye technique will give you much greater control over spotting then using a palette of wet dyes. You can control the amount of dye absorbed by the brush much more easily, and small amounts of colors can be mixed quite exactly. If too much dye is applied to the print, blot it quickly with the paper toweling. If too much dye is absorbed or if it is in the wrong color, a drop of 5 percent ammonia water should be used to remove the spot. Let it stand about 1 minute, then blot. Cover with plain water, then blot again. After the print dries, you may resume spotting.

After the dyes dry in the print, the original surface texture should return. If there is a difference in reflectance in the spotted print areas, you may want to spray the print surface with a print lacquer. Several brands of such lacquers are available at most photography supply stores.

Pencil Retouching: Prints from Negatives. Many spots may be easily eliminated by using soft colored pencils.

Step 1 Spray the print with a retouching lacquer. This will give the print a matte texture, which will conceal the pencil marks.

Step 2 Use a pencil of an appropriate color to match print color around the spot.

Step 3 Spray the print with retouching lacquer to cover the pencil marks, if necessary.

Prints from Transparencies. Color matching with either dyes or pencils is accomplished in the same manner for prints from transparencies as for prints from negatives. The main difference is that dust spots will appear black, not white. These black spots must first be covered with a white spotting opaque, then colored. They may also be spotted with colored spotting opaque. In either case, there *will* be a difference in reflectance between the print surface and the retouched area. This difference can be eliminated by spraying the retouched print entirely with a photo lacquer.

Print Mounting. To display a print properly, and to protect it from fingerprints, cracks, bends, and other destruction resulting from handling, the best solution is to mount the print on a sturdy sheet of mat board.

Inexpensive mat boards contain acids and other contaminants which can migrate to the print and damage the color image. You should use a "conservation" board, low or neutral in acid content, to mount prints on.

Prints may be adhered to mat board with either cold or heat mounting processes. Adhesive sprays, rubber cement, and animal glues are not recommended because they contain contaminants not compatible with print longevity. Remember that mounting should be done only after the print has been spotted, in case any further washing or spray lacquering is needed.

4-64 Spray the print with a retouching lacquer.

4-65 Use a pencil of an appropriate color, then repeat the steps until the spot is removed.

COLD-MOUNT PROCESS: For this demonstration, Cold Mount, by Coda, is used.

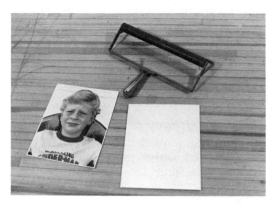

4-66 Gather a Cold Mount sheet, a Cold Mounter, and a print to be mounted.

Step 1 Trim borders from the print if necessary, and make sure release paper is the same size.

Step 2 Start removal of the release paper in one corner by lifting with a pin or a bit of clear plastic tape. Peel back about two inches of release paper, then fold down.

Step 3 Line the print up on the three edges still covered by the release paper. The folded portion will keep it from sticking to exposed adhesive. Tack with finger pressure over exposed end of adhesive.

Step 4 Working on a hard flat surface, first press the roller of the Cold Mount down on the tacked portion of the print. Slip the unmounted portion under the bar. With your free hand, peel off the release paper. The print can then be rolled down.

4-67A Step 2

4-67B Step 3

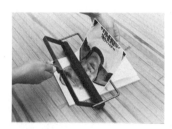

4-67C Step 4

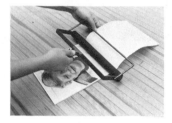

4-67D Step 4

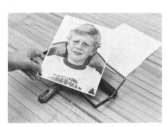

4-67E Finished Cold Mount

HEAT-MOUNT PROCESS: For this demonstration, Kodak Dry Mount Tissue, Type 2, is used.

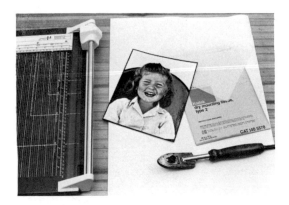

4-68 Gather necessities for heat-mount process.

4-69 Place print face down on a clean surface, and lay tissue on back.

Step 1 Tack the heat-sensitive tissue to the center of the print, using a tacking iron (available at photo supply stores) or a clothing iron. If a clothing iron is used, set the temperature at the lowest synthetic fabric, and adjust if necessary. Do *not* use this iron for clothing!

Step 2 Trim the print borders and any image area not desired. This trims the tissue at the same time.

Step 3 Position the print on the mat board, then lift one corner of the print and tack the tissue to the board. Move your iron to an adjacent corner and tack the tissue there as well.

Step 4 Whether a dry mount press or a clothing iron is used to heat the whole print-tissue-board combination, the print should be covered by a clean sheet of white paper for protection. Keep the print in the press for about 45 seconds, or move the clothing iron over the covered print for about the same time. Don't press too hard with the iron, or you may damage the print.

Step 5 After the print is adhered to the board, place it face down on a clean surface, place a heavy book on its back to keep it flat, and allow it to cool.

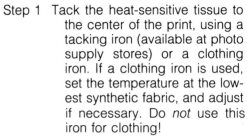

4-70A Step 1 **4-70B** Step 2 **4-70C** Step 3

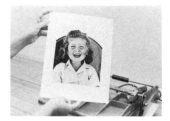

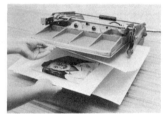

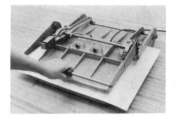

4-70D Step 3 **4-70E** Step 4 **4-70F** Step 4

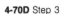

4-70G Finished heat mount

Print Permanence. Black-and-white print materials can usually be processed to *archival* standards for incredibly long life. Color prints, however, contain none of the silver that makes such permanence possible. The most important factor affecting the longevity of a color print is the processing it receives. If the manufacturer's instructions are *not* followed in processing, you may seriously impair the useful life of your color prints. No amount of care in their storage and display will remedy the situation.

If you *have* properly processed your pictures, then you need to consider the elements that may contribute to deterioration of the color image. Proper storage and display of color pictures can greatly extend the life of a print.

It is important to remember that not all color prints will resist fading equally well. Print life is affected by a number of factors, among them: the dyes that form the image; the stability of the base support; temperatures to which the print is exposed; humidity,

chemical vapors, and air pollution in the environment; and exposure to ultraviolet light. To the extent that the temperatures, light levels, humidity, and pollution levels can be kept low, you can make a positive impact on print life.

The variables associated with choice of print paper are determined by the manufacturer, and, other than choosing one paper over another, you cannot control their effect on your prints. Many studies have been undertaken to evaluate color print fading among the various paper brands available, and all manufacturers are actively engaged in research aimed at improving print life. It is generally conceded that prints made with metallized Azo dyes, such as Cibachrome A-II, have the most stable image structures. Not only are these dyes highly resistant to fading, but when they do fade, all three layers are affected almost equally so very little apparent color "shift" results. Prints containing chromogenically produced dyes are inherently less stable than papers made with Azo or other integral dyes.

Paper bases also play a role in print stability. Properly processed fiber-based papers would be ideal but are produced in only limited quantities for specialized processes. Of the synthetic paper bases available for most work, studies have shown the polyester base to be less prone to cracking and discoloring over time than resin coated bases.

While papers are available with both highly stable and relatively unstable characteristics, there is *not* a mass movement of photographers to the more archival materials. There are a number of reasons for this. One factor is cost: the more stable materials cost almost three times as much as less stable processes. Another factor is the slide-printing-only limitation of more stable materials. The third, and probably most decisive, factor is the word "stable" itself. Under normal viewing conditions, a change in the less stable print won't be noticeable for a number of years, and the pictures most people print aren't meant to be museum pieces anyway. If you are printing your work for posterity, can afford the expense, and shoot only transparencies, then by all means use only Cibachrome A-II or have your prints made by the dye transfer process. However, if you are not overly concerned with these three factors, choose your color print process based on a paper's unique color palette or contrast, its surface texture, your finances, or some other important factor. You might well end up choosing Cibachrome anyway.

Print Storage. Whether their prints are mounted or not, all photographers face the problem of what to do with all those pictures. Unless you are a *very* actively exhibiting—and selling—artist, many of your prints will require storage. Proper storage should protect the prints from damage while at the same time making them accessible.

Unmounted prints to which you do not need immediate access should be stored in an airtight container in your refrigerator or

freezer. We have already noted that light, heat, and humidity affect print stability, so what better place than a dark, cool refrigerator to store your work? Boxes and envelopes in which your fresh color paper are packaged make ideal storage containers in this case.

The prints should be interleaved with a smooth-surface, ph neutral paper to protect image surfaces from scratching. The humidity at the time prints are sealed in packages should be low, about 25 percent. A list of negative numbers or titles for the prints should be taped to the box for easy reference.

When retrieving a print from storage, avoid condensation problems by waiting at least *three hours after* the box is removed from the refrigerator before opening the envelope.

Mounted prints are usually intended for display. If the print is to be framed, a window mat must first be cut and put in place. The window acts as a spacer between the print and glass and also gives a professionally finished effect. Be sure to use ph neutral mat board over the print as well as under it.

Whichever frame and mat combination you choose, you should try to avoid using window glass to complete the package. Glass

4-71 To aid in retrieval of finished color prints stored in a refrigerator, be sure to note the contents on storage boxes.

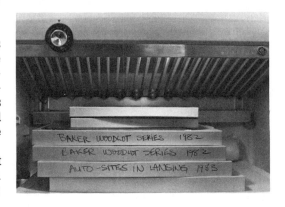

acts as a light green filter and will alter the color of the print you worked so hard to balance. It also allows most ultraviolet radiation to pass right through and commence fading your print's dyes. While acrylic sheets are certainly more expensive, and are easily scratched, they *do* block some ultraviolet rays and *do not* give a color cast to your pictures. A specially made acrylic sheet with an ultraviolet filter built in is ideal when long exposure to sunlight or fluorescent tubes is unavoidable.

BIBLIOGRAPHY

The books and magazines listed below would form the core of a quality photographic library. Your success as a photographer will depend on your breadth of understanding of the medium. Happy reading!

History of Photography

Eder, Joseph Maria, *History of Photography*. Dover Editions, 1978. A reprint of the 1932 edition, translated from the German. An extensive survey, without illustrations, of the important and ephemeral.

Gernsheim, Helmut and Alison, *The History of Photography from the Camera Obscura to the Beginning of the Modern Era*. McGraw-Hill, 1969. A cogent, well-illustrated text by a couple whose research and collection were among the best in the medium.

Mees, C. E. Kenneth, *From Dryplates to Ektachrome Film*. Ziff-Davis, 1961. Dr. Mees was the driving force behind Kodak's color research. This is his story.

Newhall, Beaumont, *The History of Photography from 1839 to the Present Day, 5th ed.* The Museum of Modern Art, 1982. Friend of many of the best contemporary photographers, first photography curator at MoMA, teacher, and prolific writer, Newhall puts it all into perspective.

Pollack, Peter, *The Picture History of Photography*. Abrams, 1958. Profusely illustrated, this makes a good supplement to books with more text.

Sipley, Louis W., *A Half-Century of Color*. Macmillan, 1951. One of the most important books on color photography and color printing ever produced. Beautiful illustrations, many tipped in, written with enthusiasm.

Magazines

Afterimage. Visual Studies Workshop, Rochester, NY. Invaluable for the contemporary video or photographic artist. A good review of current exhibits, books, and artists.

American Photographer. CBS Publications, New York, NY. A variety of approaches, from fine art to pure commerce, written with respect for concept as well as technique.

Aperture. Aperture, Inc., Millerton, NY. Begun by Minor White, it has published a no-technique, all-aesthetic, exquisitely reproduced volume about four times a year for over 30 years.

The Archive. Center for Creative Photography at the University of Arizona, Tucson. A benefit of membership in the Center, it is a quarterly monograph on an artist represented in the collection.

Modern Photography. ABC Leisure Magazines, New York, NY. A monthly variety of articles balanced fairly evenly between pure technique and purely pictorial. Terrific for comparing prices and quality of equipment.

Popular Photography. Ziff-Davis, New York, NY. A monthly variety of articles, with the balance being tipped a little more toward the pictorial than the technical. The yearly "annual" is a good overview of current trends.

Untitled. The Friends of Photography, Carmel, CA. The quarterly journal of the Friends, this is well written and beautifully illustrated. Sometimes focuses on a single artist, sometimes on a group theme.

General Technique

Craven, George, *Object and Image*. Prentice-Hall, 1982. An introductory text to both photography and the reader's ability to think and see photographically. Camera and darkroom technique, history, and special applications are all well outlined.

Davis, Phil, *Photography*. W. C. Brown & Co., 1982. An introductory text by an author well-known for his versatility in the darkroom and behind a camera. Among the most accurate in technical information.

Hattersly, Ralph, *Photographic Lighting*. Prentice-Hall, 1978. A wide variety of artificial lighting techniques, presented in an informal, accurate style.

Hurter, B., *Techniques in Portrait Photography*. Prentice-Hall, 1983. A comprehensive review of this subject.

Editorial Staff, *The Photo Lab Index*. Morgan and Morgan, 1982 and rev. *The* most valuable reference book ever compiled for photographers. Put this one high on your list.

Color

Eastman Kodak Co., *Color as Seen and Photographed*. Publication E-74. An excellent overview of basic principles.

Eastman Kodak Co., *Kodak Dye Transfer Process*. Publication E-80. A concise, well-organized, easily digested treatment of this beautiful, difficult printing process.

Evans, Ralph M., *Eye, Film and Camera in Color Photography*. John Wiley & Son, 1969. Vision, expression, and photographic theory are blended in an understandable, logical manner.

Evans, Ralph M., *An Introduction to Color*. John Wiley & Son, 1948. A standard reference work, presenting a variety of approaches to the concept of color.

Gassan, Arnold, *The Color Print Book*. Light Impressions, 1981. A survey of contemporary color photographic printmaking processes, with emphasis on the esoteric and manipulative.

Creative Photography

Capa, Cornell, ed., *The Concerned Photographer, Vols. 1 and 2*. Grossman, 1968, 1972. A stirring compilation of work by photographers who believe in life as subject.

Gibson, Ralph, ed., *SX-70 Art*. Lustrum, 1979. Polaroid SX-70 photographs by a number of contemporary photographers, *beautifully* reproduced.

Jay, Bill, *Negative/Positive*. Kendall/Hunt, 1979. A searing indictment of many contemporary theories of photographic art, and strident argument for the author's notions. This book will challenge you to form an honest philosophy of photography.

Kubler, George, *The Shape of Time*. Yale Press, 1962. A challenging thesis that expands the notion of art.

Lyons, Nathan, ed., *Photographers on Photography*. Prentice-Hall, 1966. There are no illustrations in this compilation of comments on their art by the photographers. They

aren't needed, as the words are exciting enough.

Petruck, Peninah, *The Camera Viewed, Vols. 1 and 2*. E. P. Dutton, 1979. Articles by and about photographers from before and after World War II. An excellent variety, giving a good overview of photographic concerns in different periods.

Szarkowski, John, *Looking at Photographs*. Museum of Modern Art, 1973. One hundred photographs from the collection of MoMA, with commentary on each by the most influential tastemaker in contemporary photography.

Szarkowski, John, *Mirrors and Windows*. Museum of Modern Art, 1978. Profusely illustrated essay on the aesthetics of photography since 1950.

Safety

Shaw, Susan, *Overexposure: Health Hazards in Photography*. The Friends of Photography, 1983. A comprehensive review of the health hazards photographers may be exposed to, with valuable suggestions for means of protection. *Every* darkroom worker should read this book.

INDEX

Absorption, 22
Activator, Ektaflex, *71*
Additive primary colors, 2, 4, *26*, 27
Additive theory of light, 2, 4, 5, 37, *CP 1*
Agfa color plates, 12, *12*
Agfacolor, 12, 14
Archer, Frederick Scott, 4
Archival framing, 112
Archival quality of prints, 110, 111
Archival storage, 111, 112
Artificial light, 36, *36*
Autochrome plates, 9, *9*

Becquerel, Edmond, 2
Beseler CN-2 chemistry, 39
Black-and-white prints, 103

*Illustrations are indicated by *italic* type.

Black light, 25
Bleach, and dye destruction, *70*
Bleach-fix, *67*, *69*
Blix (*see* Bleach-fix)
Brightness, 26
Brightness constancy, 30
Burning, 98, *98*, 99

Cameras:
 Hi-Cro, 10
 Ives' one-shot, *10*
 Kodak Instamatic, 15, *15*
 Number One Kodak, 11, *11*
 Polaroid SLR 680, *15*
 Polaroid SX-70 Sonar, 15
 Polaroid 20″ × 24″, 15, *16*
 Sony Mavica, 16
Capstaff, J.G., 11
Carbro color prints, 14

Chemistry contamination, 79
Chroma, 26
Chromogenic dyes:
 definition, 66
 discovery, 7
 research, 10
Chromogenic prints, 66, *67*, 68, 69
Cibachrome:
 development theory, 68, *68*, 69, *69*
 dye stability, 69
 emulsion structure, 68
 first introduced, 14
Cibachrome A-II:
 archival quality, 111
 paper supports, 72
Clerk-Maxwell, James, 4
Cold-mount process, *108*
Collodion process:
 color sensitivity, 4, 5
 invention of, 4
 sample exposure times, 6
Color:
 complements, *CP 1*, 6, 27, *27*, 28
 cool, 32
 harmonious combinations, 32
 meanings, 33
 mood, 32, 33
 perception, 29. *29*
 warmth, 32
Color analyzer, *99, 100, 101, 102*
Color balance of film, *CP 11, CP 12*
Color Compensating (CC) filters, 55
Color constancy, 30
Color Conversion filters, 53, 54 (Table 3.9)
Color coupler print, 66
Color description:
 brightness, 26
 chroma, 26
 hue, 26
 ROY G BIV, 25
 saturation, 26
 value, 26
Color developer, 68, *68*
Color film:
 basic process outline, 39
 common processing procedures, 42, *43*, *44*

cross section, *38*
how to choose one, 38, 39
negative, 38, 39
negative exposure latitude, 38
negative exposure through development, *40*
negative processing chemistry, 41
negative processing steps, *45*
reversal, 37, 38
reversal exposure latitude, 38
reversal exposure through development, *41*, 42
reversal process steps, *47*
reversal process steps summarized, 47 (table 3.5)
stability, 64, 65
storage and mounting, 42, *50*
Color-light phenomena:
 absorption, 22
 diffraction, 22, 23, *CP 9*
 dispersion, 20, *21*
 fluorescence, 23, 25
 interference, 23
 refraction, 20, *21*
 scattering, 22, *23*
Color print:
 balance, 79, 82
 dye fading, 110, 111
 evaluation, 82
Color Print (CP) filters, 75, 76
Color print systems theory:
 Ektaflex PCT, 69
 negative to positive, 66
 transparency to dye destruction, 68
 transparency to reversal, 68
Color print viewing filters, 76, *83*
Color spectrum, *CP 1*
Color transparencies from negatives, 104, 105
Color vision:
 Land theory, 29, 30
 Young/Helmholtz theory, 29
Color wheel, 32, *CP 1*
Cones, 28
Contact sheet, 97, *97*, 98, *98*
Continuous spectrum, 20
Cornea, 28
Cros, Charles, 6, 10

D

Daguerre, Louis Jacques Mandé, 2, *3*
Daguerreotype, 2, 3, 4, *4*
Darkroom:
 cleanliness, 42
 color analyzer, 99, 100, 101, 102
 easel, 74, *74*
 enlarger, 74, 76
 lightleaks, 73, *73*
 printing filters, 74-76
 processing drum, *78*
 requirements for printing color, 72
 safelight, 74, *74*
 temperature controller, *77*
 temporary storage, *73*
 voltage regulator, *77*
Daylight film, 52, 53, *CP 11*
De Dominus, Antonius, 1
Developer effect:
 dye destruction paper, 70, *70*
 negative print paper, 67, *67*
 reversal print paper, 68, *68*
Diffraction, 22, 23, *24*
Discontinuous spectra, 20
Dispersion, 20
Dodging, 98, *98*
Drymounting, 107-110
Dufaycolor, *8*, *9*, 10
Dufay Dioptichrome Plates, 10
Du Hauron, Louis Ducos, 5, *5*, 6
Duratrans Display Film 4022, 105
Dye couplers, 11
Dye destruction print:
 Christenson's process, 11
 Cibachrome introduction, 14
 dye stability, 69
 emulsion structure, 68
 exposure through development, 70, *70*
Dye production, 66, *67*

E

Easel, 74, *74*

Eastman, George, 11
Eastman Kodak Co., 11
Ektachrome film introduction, 14
Ektachrome film process, 47, *47*, 48, *48*
Ektachrome paper, 68, 69
Ektacolor paper, 66, *67*
Ektaflex PCT process, 70, *70*, 71, *71*, 72, *72*
Ektaflex PCT System introduction, 16
Ektaprint process, 84, *84*, 85, *85*, 86, *86*, 87
Electromagnetic radiation, *20*
Emulsion of paper, 66, 103
Enlarger, 74, 76
Evans, Ralph M., 5
Exposure of prints, 67, *67*, 68, *68*, 70, *70*, 98, 99
Eye, 2, 28, *29*

F

Film:
 cross-section, *38*
 Ektachrome, 47, 48
 infrared, 53, *CP 10*
 Polachrome, 61, 62, 63
 Polacolor 2, 58
 Polaroid SX-70, 59
 storage of processed, 65
 VR 100, 45, 46
Film development:
 before and after, 42
 negative, 40, *40*, 45, *45*, 46, *46*
 reversal, 41, *41*, 42, 47, *47*, 48, *48*
Filter pack changes, 82, *83*, 83(Table 4.1), 84(Table 4.2), *CP 4*, *CP 5*
Filters, camera:
 Color Compensating (CC), 55
 Conversion, 53, 54(Table 3.9)
 FL-B, 55
 FL-D, 55
 mired system, 53, 54(Table 3.9)
 Nomograph, 56
Filters, printing:
 Color Compensating (CC), 74, 75, 76
 Color Print (CP), 75, 76
 dichroic, 76

Finlay, C.L., 9
Finlay screen, *8*, 10
First color photograph, 4
Fischer, Rudolph, 10
Fixing bath for dye destruction, effect, 70, *70*
Flexicolor chemistry:
 capacity, 46(Table 3.3)
 for negative processing, 39
 storage time, 46(Table 3.2)
 summary of steps, 45(Table 3.1)
 troubleshooting, 46(Table 3.4)
Fluorescence, 23, 25, *25*
Fovea, 28
Fuji Film Corp., 16

Gasparcolor, 11
Glare control, 22, *22*
Godowsky, Leo, 13, *13*

Hand-colored photographs, 2, *4*
Hauron, Louis Ducos du, 5, *5*, 6
Heat-mount process, 109, *109*, 110, *110*
Heliochrome, 3
Herschel, Sir John, 2
Hi-Cro camera, 10
Hill, Rev. Levi L., 3
Hillotype process, 3, 4
Homolka, Dr. B., 7
Hue, 26
Huygens, Christian, 2

Ilford poison hot-line, 79
Imbibition print process, 10

Infrared film, 53, *CP 10*
Infrared light, *21*
Instant film processes:
 Polachrome, 61, *62*, 63, *63*
 Polacolor, 57, *58*
 Polaroid SX-70, *59*, 60, 61
Integrated screen processes, 9, 10
Interference process, 7
Interference, 23, *24*
Iris, 28, *29*
Ives, Frederick E., 8

Joly, Charles, 8

Kelvin Temperature:
 determination, 20
 and film emulsion balance, 52
 light color, 20
 scale of light sources, *52*
Kodachrome film, 12, *13*, 14
Kodacolor film and prints, introduction of, 14
Kodak:
 Duratrans Display Film 4022, 105
 Ektachrome film, 14, 16, 47, *47*, 48, *48*
 Ektachrome paper, 68, 69
 Ektacolor paper, 66, *67*
 Ektaflex PCT process, 70, *70*, 71, *71*, 72, *72*
 Ektaprint process, 84, *84*, 85, *85*, 86, *86*, 87
 Instamatic camera, 15, *15*
 Number One camera, *11*
 Paper Filter Adjustment Number, 103
 poison hot line, 79
 Vericolor Print Film 4111, 104
 Vericolor Slide Film 5072, 104
 VR films, 16; *17*, 45, *45*, 46, *46*
Kromograms, 8

L

Lamination of Ektaflex, 71, *71*
Land, Edwin, 14, *14*, 15, 29, 30
Land Theory of Color Vision, 29, 30
Le Blon, Jakob Christoph, 2
Light:
 absorption, 22
 artificial, 36, *36*
 continuous spectrum, 20
 diffraction, 22, *24*
 diffuse reflections, 22
 discontinuous spectra, 20, 55
 dispersion, 20, *21*
 electromagnetic radiation, 19
 energy, 19
 fluorescence, 23, 25, *25*
 fluorescent, 55
 interference, 23, *24*
 Kelvin temperature, 20, 52, *52*
 polarized, 22, *22*
 psychology of, 31
 refraction, 20, *21*
 scattering, 22, *23*
 spectrum, 19, 20, *21*
 specular reflection, 22
 speed of, 19
 visible spectrum, 19, *21*, 25
 wavelength color, 19
 wavelength measurement, 19, *20*
Lightleaks, 73
Light source effect on color:
 afternoon, 34
 dawn, 34, *CP 7*
 daylight, 33
 midday, 34, *CP 8*
 morning, 34,
 nightlight, 34, *CP 19*
 predawn, 33, *CP 6*
 sunset, 34, *CP 18*
 twilight, 34
Light source effect on shape and form, 31,
 32, *34*, *36*
Light and weather:
 fog, 35, *CP 17*
 mist, 35, *35*
 rain, 35, *CP 16*
 snow, 35
Lippmann, Prof. G., 7
Lumière, Auguste and Louis, 9

M

Manly, Thomas, 10
Mannes, Leopold, 13, *13*
McDonough, James W., 9
Mees, C.E. Kenneth, 11, 13
Miethe, Professor A., 6
Mired system:
 chart of shifts, 54(Table 3.9)
 description, 54
 Nomograph, *56*
Morse, Samuel F.B., 4
Mounting prints, 107, *107*, *108*, *109*, *110*
Mounting transparencies, 50, *50*, 51, *51*

N

Negative chromogenic print, exposure and
 development, *67*
Negative film:
 daylight and tungsten emulsions, 52, 53
 processing steps, 39, *40*, 44(Table 3.1), 45,
 45, 46, *46*
 storage, 50, *50*
 structure, 37, 38, 39
 troubleshooting for processing, 46(Table
 3.4)
 Type L, 53
 Type S, 53
Neutral density, 27, 76, *CP 1*
Newton, Sir Isaac, 1, *1*
Niepce, Joseph Nicephore, 2, *3*
Niepce de St. Victor, Abel, 2, 3,

O

Orthochromatic paper, 103
Ozobrome print process, 10

Panalure paper, 103
Panchromatic emulsions:
 advantages over collodion, 6
 development and research, 7
 dyes used to extend sensitivity, 6, 7
Paper:
 changes in emulsion batches, 103
 filter adjustment number, 103
 supports, 69, 70
Pencil retouching, 107
Perception:
 afterimage, 30
 brightness adaptation/constancy, 30
 color constancy, 30
 simultaneous contrast, 30, 31
Photochromoscope, 7, 8
Photography:
 definition, 19
 first, 2, 3
 first in color, 4
 hand colored, 2, 4, CP 3
 outer space, CP 2
Pinatype print process, 10
Polachrome CS 35mm film, 16, 61, 61, 62, 62,
 63, 63
Polacolor film, 14, 57, 58
Polaroid Corporation, 14, 14, 15, 15, 16, 16
Polaroid SUN 600 System, 15, 16
Polaroid SX-70 film, 15, 59, 60, 61
Polaroid 20″ × 24″ camera, 15, 16
Print:
 color correction, negative to positive,
 84
 color correction, positive to positive, 83
 determining exposure for, 81, 82
 determining filter pack for, 82
 development, negative to positive, 84, 84,
 85, 85, 86, 86
 development, negative to reversal PCT,
 95, 95, 96, 96
 development, transparency to dye
 destruction, 92, 92, 93, 93, 94, 94
 development, transparency to reversal,
 88, 88, 89, 89, 90, 90

finishing techniques, 105–10
mounting, 107–10
permanence, 110, 111
processes common to different, 80, 80, 81,
 81
spotting, 105, 105, 106, 106, 107, 107
storage, 111, 112
Processing drum, 77, 78, 78
Proofing negatives, 97, 97, 98, 98
Pupil, 28
Push processing, 49, 51 (Table 3.8)

RC paper, 69
Reciprocity effect, 55
Reference picture, 79, 100, 101
Reflection, 22
Refraction, 20, 21, CP 9
Resin coating, 69
Retina, 28, 29
Retouching prints, 105, 106, 107
Reversal chromogenic print, exposure and
 development, 68, 69
Reversal film, 50, 51, 52, 53
Reversal film processing:
 push, 51
 troubleshooting, 49(Table 3.7)
 steps, 47(Table 3.5), 47, 48
Ring around:
 prints from negatives, CP 5
 prints from transparencies, CP 4
 use in evaluating prints, 82
Rods, 28, 29
ROY G BIV, 25

Safelight, 74, 74
Safety, 78, 79
Saturation, 26
Scattering of light, 22, 23
Scheele, Carl Wilhelm, 2

Sclera, 28, *29*
Screen pattern emulsions, *8*
Screen plate photography, 5
Screen process color:
 Agfacolor, 12
 drawbacks, 5
 Dufay, 9, 10
 Dufaycolor, *8, 9*
 Du Hauron's theory, 5
 Finlay, *8, 9*
 integrated screens, 9, 10
 Joly's process, 8
 Lumière Autochrome, 9
 McDonough's process, 8, 9
 Polachrome, 61
Simultaneous contrast, 30, *31*
Smith, Dr. J.H., 10
Sony Mavica camera, 16, *18*
Spectrum:
 continuous, 20, *21*
 discontinuous, 55
Spotone, 105
Spotting prints, 105-107
Standard negative/transparency, 79
Stereoscopic view, *CP 2*
Storage:
 film envelopes, 65, *65*
 negatives and transparencies, 50, *51, 64*
 prints, 111, 112
Storage time:
 Cibachrome P-30 chemistry, 94(Table 4.13)
 Ektaprint 2 chemistry, 87(Table 4.5)
 Flexicolor chemistry, 46(Table 3.2)
 Unicolor Rapid E-6, 49(Table 3.6)
 Unicolor RP-1000, 90(Table 4.9)
Subtractive color, *27*, 28, *CP 1*
Subtractive primary theory, 6, 37, *CP 1*
Sunset, 34, *34, CP 18*
Sutton, Thomas, 4

Talbot, William Henry Fox, 2
Talbotype, 2

Temperature control, 77, *77*
Theories of color vision, 2, 29, 30
Three-color printing process, 2
Transparencies (*see* Reversal film)
Traube, Dr. A., 6
Troubleshooting:
 dye destruction print processing, 94(Table 4.14)
 negative film processing, 46(Table 3.4)
 PCT print processing, 97(Table 4.16)
 prints from negatives, 87(Table 4.6)
 reversal film processing, 49(Table 3.7)
 reversal print processing, 91(Table 4.10)
Tungsten film, 52, 53
Type C print, 66

Ultraviolet filters, 76
Ultraviolet light, *20, 21*
Unicolor Rapid E-6 process, 47, *47, 48*, 49
Unicolor K-2 chemistry, 39
Unicolor RB paper, 66
Unicolor RP-1000 process, 87-91
Utocolor print process, 10

Value, 26
Visible spectrum, *21*, 25, *CP 1*
Vision, 29, 30, 31, *31*
Vogel, Dr. H.W., 6
Voltage regulator, 77, *77*

Water bath for temperature control, 77
Weather effect on light color, 35, 36, *CP 16, CP 17*

White light theory:
 additive color, 2, 4, 5, *26*, 27, *CP 1*
 of Antonius de Dominus, 1
 definition of white light, 19
 of Louis Ducos du Hauron, 5
 of Sir Isaac Newton, 1
 subtractive color, 6, *27*, 28, 37, *CP 1*

Young, Thomas, 2, 4